D0621222

RÍO L.A.
TALES FROM THE LOS ANGELES RIVER

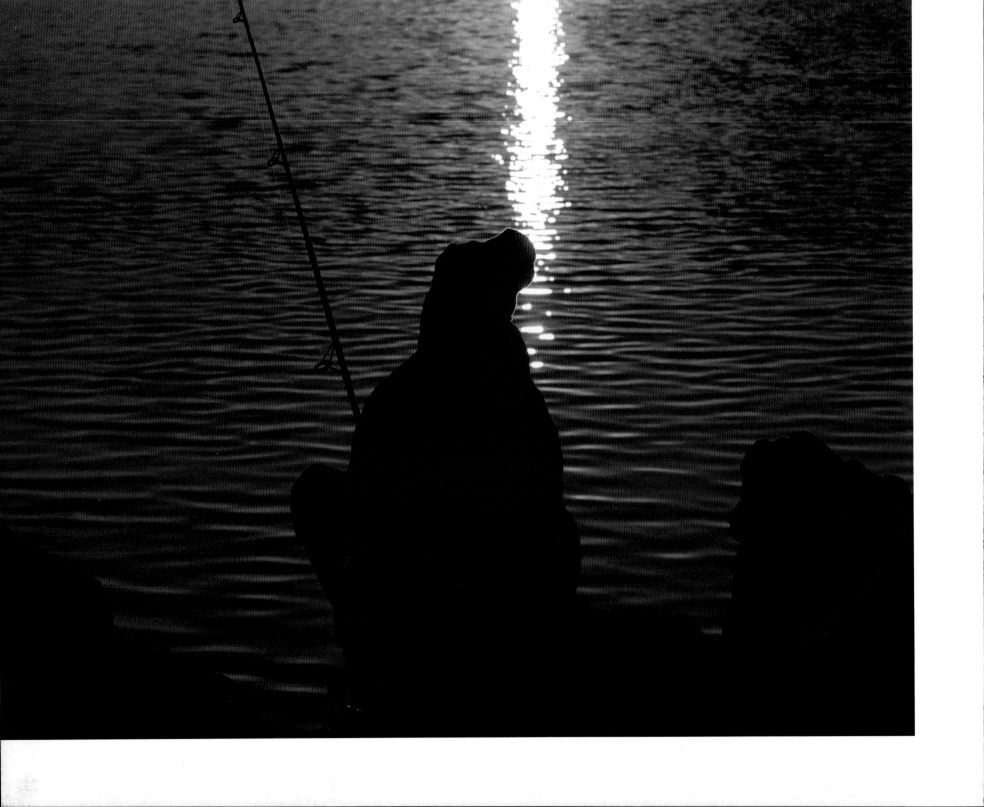

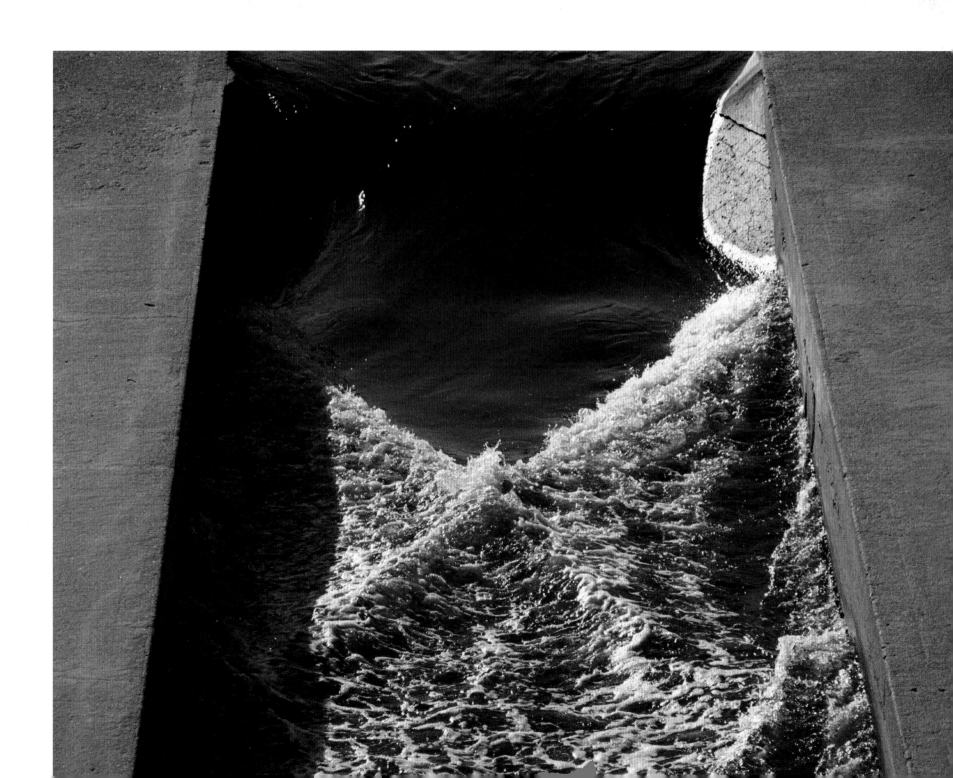

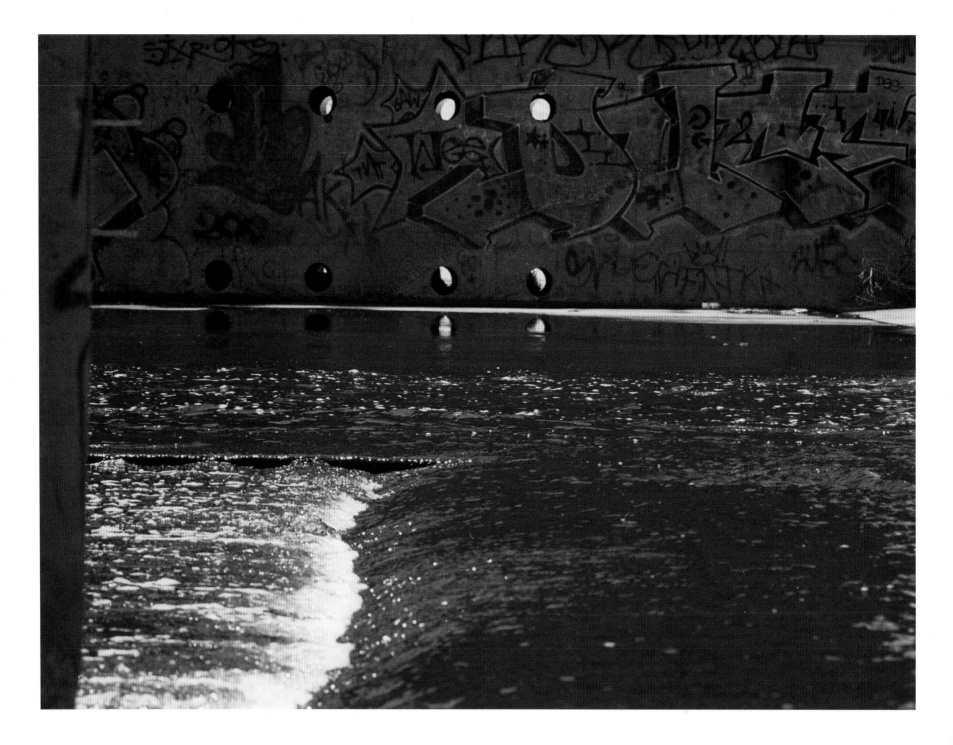

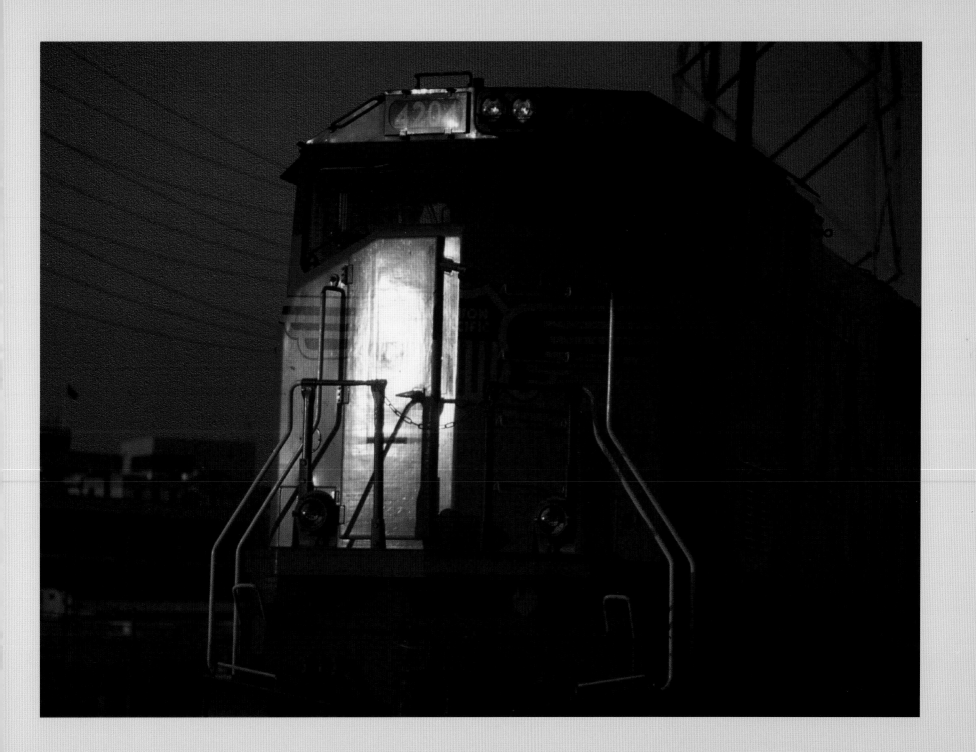

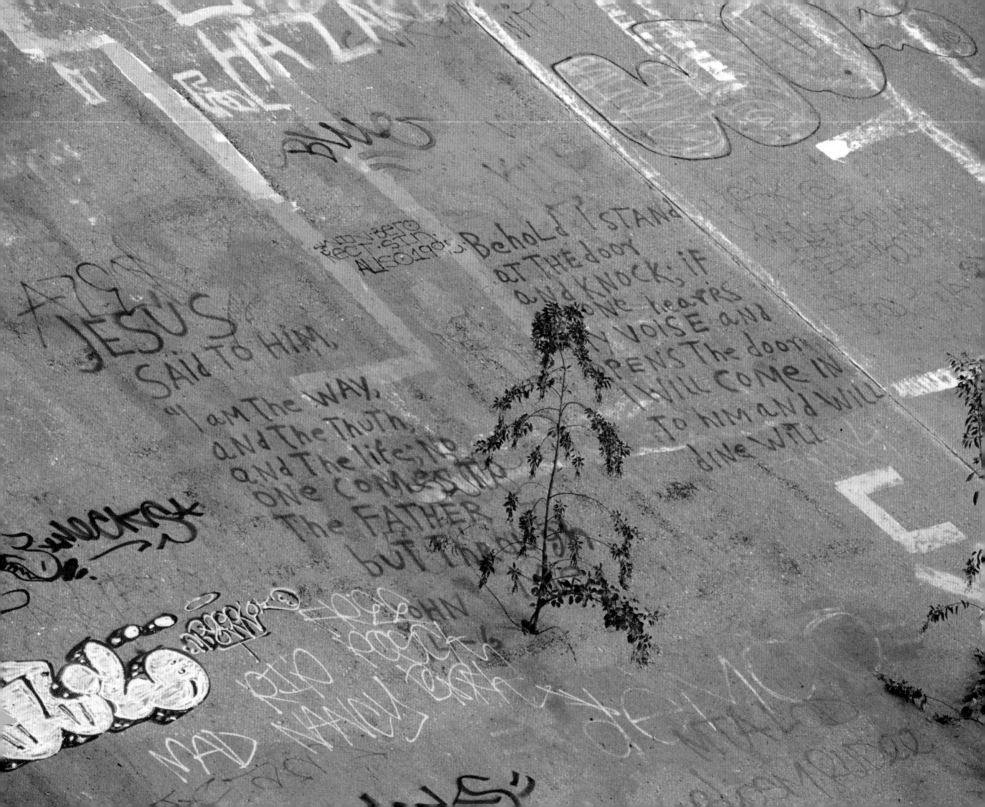

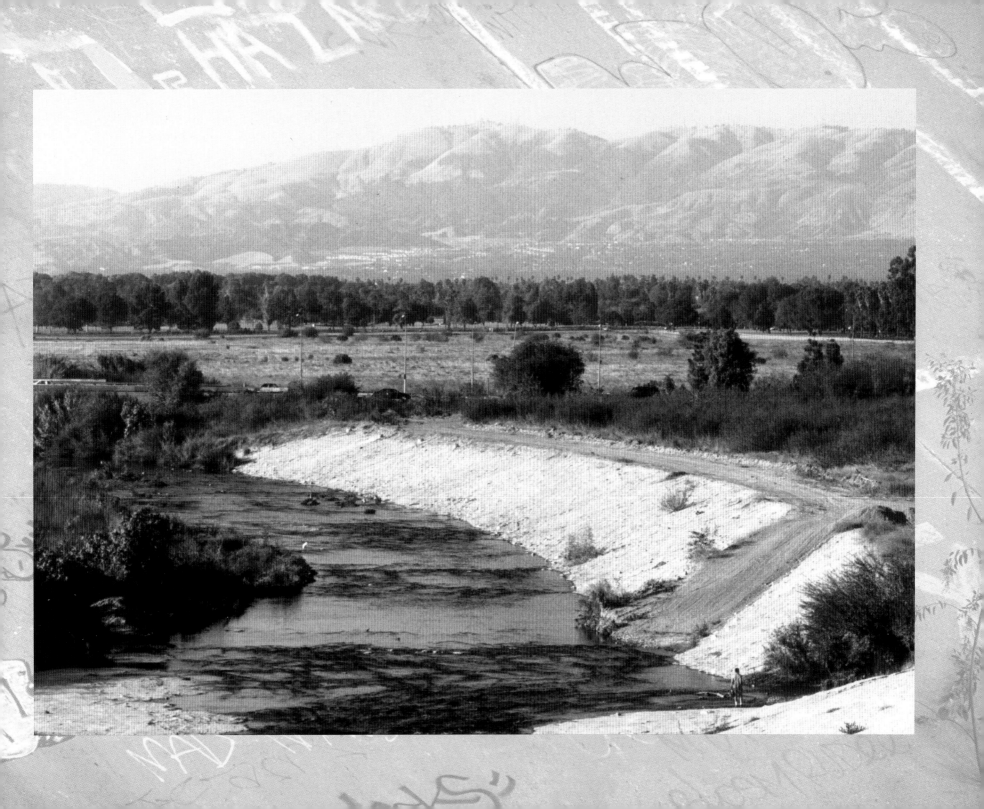

RÍO L.A.
TALES FROM THE LOS ANGELES RIVER

PATT MORRISON

PHOTOGRAPHS BY
MARK LAMONICA

FOREWORD BY KEVIN STARR
DESIGN BY AMY INOUYE
DEVELOPED BY CHARLOTTE GUSAY

ANGEL CITY PRESS
SANTA MONICA 2001

ANGEL CITY PRESS
2118 Wilshire Blvd., #880
Santa Monica, California 90403
310.395.9982
www.angelcitypress.com

Río L.A.
by Patt Morrison and Mark Lamonica

Copyright © 2001 by Mark Lamonica and Patt Morrison
Photographs copyright © 2001 by Mark Lamonica
Foreword text copyright © 2001 by Kevin Starr

Design by Amy Inouye
First edition
10 9 8 7 6 5 4 3 2 1

ISBN 1-883318-24-6

All rights reserved. No part of this book may be reproduced or transmitted in any form or by any means,
electronic or mechanical, including photocopying, recording,
or by an information storage and retrieval system, without express
written permission from the publisher.

Brand names and trademarks of products are the property of
their registered owners.

"To Artesia" from the book *The River: Books One & Two* is used
by permission of Lewis MacAdams. Copyright © 1998 by Lewis
MacAdams. Published by Blue Press 1998. All rights reserved.

"Los Angeles New Year's Flood"—words and music by Woody
Guthrie. TRO—copyright © 1963 (renewed). Ludlow Music, Inc.,
New York, New York. Used by permission.

Lyrics from the song "L.A. River" from the album *Broken Toy Shop* copyright © 1993, Polygram International
Publishing Inc. and Vitamin E Music are used by permission of the copyright holder.

LIBRARY OF CONGRESS CATALOGING-IN-PUBLICATION DATA
Morrison, Patt, and Mark Lamonica
Río L.A. : tales from the Los Angeles River / by Patt Morrison ; photographs by Mark Lamonica. — 1st ed.
p. cm.
Includes index.
ISBN 1-883318-24-6 (hardcover : alk. paper)
1. Los Angeles River (Calif.)—History. 2. Los Angeles River Calif.)--Description and travel. 3. Los Angeles River
(Calif.)—Environmental conditions. I. Title: *Río Los Angeles*. II. Lamonica, Mark. III. Title
F868.L8 M75 2001
979.4'93—dc21
2001001787

Printed in China

To my mother
Alda Dolores Lamonica
and the magnificent
Native Americans who once
roamed this majestic River.
—M.L.

To my beloved family,
who go on two legs and on four.
—P.M.

FOREWORD

So many of the great cities of the world—London, Rome, Paris, Budapest, New York, Boston, Minneapolis, Pittsburgh, St. Louis—are riverside cities. And so is Los Angeles. Yet in contrast to the Thames, Tiber, Seine, Danube, Hudson, Charles, Mississippi, Allegheny, Monongahela, or Missouri, the Los Angeles River does not sweep majestically past its city in unchallenged supremacy. Ever since it was buried under tons of concrete in the late 1930s, the Los Angeles River has all but lost its identity, at least in comparison to so many other rivers sweeping so arrogantly past their cities. Nor has the Los Angeles River received any testimony comparable to the final paragraphs of the *Great Gatsby* (1925) in which F. Scott Fitzgerald extolled the Hudson as the waterway into the American future.

And yet the Los Angeles River, ever present in the history of the city, is inextricably linked to the identity and meaning of the City of Angels. In ages past, the river protected in the bend of its crooked arm the Native American village of Yangna, somewhere in the vicinity of present-day Elysian Park. In time, the river no longer sufficed to serve the growing city. By 1913, no longer was it the sole or even the main artery of the City of Angels. It had been replaced, rather, by waters arriving from the Owens Valley via the Los Angeles Aqueduct and in less than three decades after that by the waters of the mighty Colorado River, the Mississippi of the far west.

Yet the Los Angeles River refused to be ignored! From its heightened and volatile watershed, the Los Angeles would gather unto itself during the rainy seasons a mighty torrent, which it released onto the floodplain of the city below, as if—or so it seemed—the river were angry at the insult of its displacement. The citizens of the City of Angels might replace the Los Angeles River as a source of water and power, but they could never ignore it, for the river, however humiliated, would not allow itself to be ignored. It would cascade from the hills through the arroyos and canyons down to the city in search of the sea, carrying all before its angry flood tide.

Finally, when the citizens of the floodplain had had enough, they canalized the river under a tombstone of concrete, which should have been the end of the story.

But it was not the end. It was only the beginning. The subjugated river now became a powerful metaphor of Los Angeles itself: for, indeed, the entire civilization of the Southland, which also had imposed its concrete and asphalt, its steel and stone, its freeways and suburbs, onto a once pristine Mediterranean shore—just as the Los Angeles River had been buried tons of concrete.

The Los Angeles River had not been lost at all! As Patt Morrison documents in this book, it had merely been transmogrified, like Los Angeles itself, into a post-modernist construction of symbolic engineering. As art, as constructed event, the river now stood interpreted, obliquely,

by Frank Gehry, indeed all of post-modernism. Everything about the river, including the funky stories attached to it (crocodiles and gang-bangers, drag car races and *Chinatown*), was reflective of the essential DNA code of Los Angeles itself: lost and found city, constructed, de-constructed, reassembled and recovered. As in the case of Paris, Rome, London, Budapest, and New York, nature and history had given Los Angeles the river it deserved: the river that spoke most directly and powerfully to its deepest identity and heart's desire.

Gone now were the nostalgia and regret, the sense of lost opportunities. Friends of the Los Angeles River was formed by people capable of sustaining a complex vision of loss and recovery, people who did not blame the river for what had happened to it but, rather, sought to heal its wounds whenever possible and to live as joyously alongside the Pharaonic interventions of the United States Army Corps of Engineers as being, if the truth be told, *so L.A.* Significantly enough, the Hispanic peoples of the city, whose ancestors had known the river in less disturbed times, now became its biggest boosters. In Sacramento, thanks in great measure to elected officials from their community, funds were set aside to embellish the river with a network of linked parks.

No, the river would never be returned it its first condition. Nor would the City of Angels ever be disassembled and displaced like a post-production movie set. What was—was! History, with all its faults and ambiguities, had come to the river, and together history and the river had conjoined to create a city, and the city, like the engineered river, had become an improbable symbol of itself: a one-of-a-kind river for a one-of-a kind city. And now, thanks to writer Patt Morrison and photographer Mark Lamonica, the river has its own wonderful book, its improbable book, one might say, filled with scattered people and incidents that somehow, like Los Angeles itself, like the river, cohere into something that is much more than merely the sum of its parts. The river has the city it deserves, and the city has the river it deserves, and the city and the river now have a book they deserve together, and we, in turn, thanks to this book, will better enjoy the City of Angels and the improbable river running through its past, present, and future identities.

—KEVIN STARR
State Librarian of California
March 2001

Go ahead and laugh;

Warner Bros. Studios backlot, Burbank

the river won't mind.

In a city of stars, it is a has-been.

In a city of bone-shaking earthquakes and blowtorch winds, it has been tamed into a toothless creature of unnatural nature.

In its latter days, its banks and beds have been plastered over with cement. It has been befouled by oil and DDT and cyanide and human sewage. It has had more market value as a movie set, more usefulness as a punch line, more potential as a freeway, than regard as a waterway.

On any given day, ten months out of twelve, there is more water in the swimming pools of Southern California than in the bed of the Los Angeles River. And short of painting the concrete riverbed the same shade of blue as a backyard swimming pool so that it resembles water—at least from the window seat of a 747—every indignity has been visited upon it. But the Los Angeles River knows what it really is.

In the leisurely centuries when its waters rippled like muscles across the broad flat belly of the yet-unbuilt city, it sustained millions of creatures that went on wing and fin and foot. Forests of willows and sycamores and ash and cottonwoods suckled at it. In its tumbling and churning course to the sea, it reduced the boulders of the mountains to the soft sand of the beaches.

The river watered the last wild native roses that once bloomed in fragrant profusion over the hills and hollows of present-day Chinatown, and the first pound of California oranges ever grown and shipped. It powered the city's printing presses and flour mills. It slaked the thirst and bathed the skins—first red, then brown, then white—of the men who dwelt alongside it.

It is as old as myth, and as patient as time, and the Los Angeles River knows what it really is.

Gary Snyder, the poet of Zen and Beat and of the spare and silent

places of the world, writes that it may be that the true river is "alive and well under the city streets," and under all that concrete, "it may be amused . . ."

NO ONE SPEAKS OF "the Los Angeles" as one speaks of "the Thames" or "the Nile."

No one gives directions using the river. People say they live north of some boulevard, or west of some freeway, but the river is a cipher, invisible, unknown, occupying no point on the civic compass. Say "the river" in Los Angeles, and you get only blank looks.

The poor river couldn't even hold onto a name. The Spaniards who came upon it in on a Wednesday, the second day of August in 1769, saddled it with *El Río y Valle de Nuestra Señora la Reina de Los Angeles de la Porciúncula*, The River and Valley of Our Lady Queen of the Angels of the Porciúncula, for the feast day honoring St. Francis of Assisi's tiny chapel in Italy, the *Porziuncola*, the "little portion." For short—all things being relative—they called this place the *Porciúncula*. Eighty years later, American soldiers were simply mapping it as *Río de Los Angeles*, the Los Angeles River.

Los Angeles brags about its beaches and its mountains. On the subject of its river, however, it is silent. Within the river's banks lies more acreage than Central Park—walled up, fenced off, locked away from human eyes, like the loony aunt hidden in the attic, not to be discussed in front of company. A city with enough bravado to sell tourists cans of "L.A. smog" could not bring itself to manufacture a single souvenir of its dismal river.

And yet for 125 years, nearly half of the life of modern Los Angeles, this unmentionable river was where the city drew every pail and cup of its water. Until 1913, the river's water, and the river's water alone, kept the city alive.

In other cities, great rivers are fringed by great houses and grand legends. St. Petersburg's palaces edge the canals of the Neva, where Rasputin drowned, full of cyanide and bullets. Slave-built plantation mansions front the reaches of the Mississippi, where a young Mark Twain learned his river pilot's trade and his storytelling one.

Not so here.

This vagabond stream was always too mercurial for the rich to entrust their homes to its banks. On a fine winter morning in 1884, any poor man who walked to the water's edge could enjoy the sight of a rich man come to ruin. John M. Baldwin, the editor of the *Daily* and *Weekly Herald*, had built his mansion near the river at the foot of what is now the north edge of Griffith Park. He put in the first golf course in Los Angeles—a private one, of course. The winter floods carried house and links away down the river and out toward the sea.

Fourth Street Viaduct

And so the rich men looked elsewhere to build their mansions, and the river was left to humbler people and lesser purposes. Such a wayward, dangerous river could only be warily entrusted with expendable and renewable enterprises like farms and ranches at its fringes. Along the rest of it, Los Angeles soon relegated all the smelly and noisy backstage work of the city.

The city's foundling shelters, the dog pound and the orphanage, found room at the river. Warehouses and slaughterhouses rose on riverfront property, and railroads and foundries, a bleach factory and an asphalt plant, the makers of aluminum and steel and fertilizer. In the 1980s, when the state wanted to complete the degradation of river and neighborhood with a prison on the river across from Boyle Heights, a group became a movement and the Mothers of East Los Angeles rose up and said, "No, enough."

UNLESS YOU HAVE BUSINESS THAT TAKES YOU TO the river, you are hard-pressed to find it with a casual look-see. It is too low to be seen from the vantage point of freeways, too trifling to be listed under "points of inter-est" in the trusty *Thomas Guide*. For most of its fifty-one miles, it is as unmarked, and as unremarked upon, as a pauper's grave.

Once it had been confined—"built," in the language of the engi-neers—the river was erased from the city's mental map as blithely as movie studios obliterated their stars' real lives and names, and rewrote them to the moguls' liking. A city whose will was steely enough to invent an image and build a megalopolis to match it had no trouble with a mere river.

The mayor of Portland, Oregon, had an inkling of that singular power to conjure and to deny. In 1939, he got a postcard from a friend that purported to show "the rivers and mountains of California." The mayor swore that those were Oregon rivers, not California ones. "What I suggest you do," he put forward, "is go down and take a picture of the Los Angeles River and let people see that. Of course there isn't any water in it, but that shouldn't make any difference to you people, as you proba-bly imagine there is."

And yet it was a river, and still is, somewhere in there. Without it

there would be no Los Angeles, and nothing tells the story of the city better than the river. Its tale is like the early verses of Genesis, of the division of water and land, and the twinned fears, both very rational, of drought and flood, of too little water and of too much.

Over two centuries, in the service of those needs and as the incarnation of those fears, the river found itself cast first as a blessing, then a monster, and, at last, a nullity.

THE LOS ANGELES RIVER IS NOT a river in the understood sense of the word, any more than Los Angeles is a city in the understood sense of that word.

Oh, it could be a lovely thing, all right. One of its tributaries, the Arroyo Seco, was so beautiful, so rich with creatures and green growing things that it moved Teddy Roosevelt to plead in 1903, "Don't let them spoil that. Keep it just as it is."

In its natural state the river was often feast or famine, flooding and parched by turns. Marc Reisner, the dean of western water writers, wrote that "Had humans never settled in Los Angeles, evolution, left to its own devices, might have created in a million more years the ideal creature for the habitat: a camel with gills."

In its engineered state, the river is like the city through which it invisibly courses. Los Angeles, in some ways as artificial as a moon base, was weaned on mirage and salesmanship. It has prospered by bending nature to its liking, from movie sets to subdivisions. And the river is the most masterly example of all.

The contradiction is stupefying to a newcomer: in a city plagued by drought, where it is against the law to hose down driveways or sidewalks, river water is called "waste water." Enough of it pours down the river's flood control systems and into the sea in one good, rainy month to supply the water needs of a million people for a year.

The patterns of the river's conduct, over the two centuries that humans have recorded them, are like the momentous opening bars of Beethoven's Fifth Symphony: da-da-da-DUM, dry-dry-dry-FLOOD.

Mount Washington

ONCE, THE RIVER FLOWED WITH THE SEASONS—so thunderously at times that, once every decade or so, it chewed away at the adobe and the wood and the brick and finally the steel of the city, until the city fought back at this vampire that sucked away at progress. They put it in a cement strait-jacket. They incarcerated it, fenced and guarded and gated it like the serial killer it could sometimes be, until it was no longer at liberty.

The river was triumphantly engineered into an orderly nothing-ness, with an efficiency that at the time made it a wonder of the modern world. Those who live within sight of its paved banks today speak with no irony of the time "when they built the river." So what if it's hideous for 360 days a year, and a hero for five? So be it.

Los Angeles was so glad, so relieved to have the river in chains that in 1940 Hollywood sent out its starlets to a dam groundbreaking, among them Jane Wyman, the wife of Ronald Reagan.

The conquest of the river was so thorough that between one generation and the next, the river vanished from Los Angeles' life and its collective memory. Its very existence slipped toward rumor, like the myth that Walt Disney's body lies cryonically suspended, awaiting the day of defrosted resurrection. No one is quite sure whether to believe that, either.

IN THIS MAGIC-SLATE CITY, accustomed to creating a landscape in one decade and wiping it clean the next, the disappearance of the river was taken nonchalantly. "Yours till the L.A. River wets its bed," the high school seniors wrote in each other's yearbooks.

In 1990 and again in 1996, reporters received invitations for the maiden voyage of the Los Angeles River Cruises—dated April 1. The powers of Los Angeles were so embarrassed by the wisecracks about this nothing of a river that in the 1950s they changed a new freeway's intended name from the Los Angeles River Freeway to the Long Beach Freeway—even before it was built.

Once the river was encased, it didn't take long for a new river-sport to become popular: how to describe the thing. A noxious trickle, humiliating as a bedwetter's blanket . . . fifty-one miles of glorified storm drain . . . the armor, the girdle, the chastity belt.

THE RIVER MOVES through the wide and busy plain like a census taker, tapping every class of Angeleno, every kind of neighborhood, every incar-nation of its history, from its unmarked source in the San Fernando Valley

of Los Angeles, through eleven more cities, to the musclebound port city of Long Beach.

The mapmakers and hydrologists and engineers fixed the beginning of the river in Canoga Park, behind the playing fields of Canoga Park High School, where Bell Creek and Calabasas Creek converge in cement symmetry.

From the woodsy property of horse-country squires in the upper San Fernando Valley, the river gurgles past the backlots of Studio City, Universal City and Burbank, the image-makers of Warner Bros. and Disney and CBS, where creators have been known to use the river as a film set in horror movies and musicals.

It lingers at the hem of Griffith Park, the biggest urban park in America, donated by a millionaire misanthrope who shot his wife in a rage and tried to buy the city's forgiveness and history's absolution with the gift of land and an observatory.

Here the river is most like a playground, the land of horses and golf, the Gene Autry Western Heritage Museum and the Bette Davis Picnic

Grounds. Along the banks here before World War I, the vogue for plumes and eggs and novelty built not one but two ostrich farms at the river's edge.

It is at Atwater, a town named not for its proximity to the river but for a local heroine, that the river does its best to defy the concrete. For about a dozen miles of its fifty-one it is allowed to behave almost like a river, and most of those miles are here. And it is also here that the street names—Crystal, Ripple, Riverside Drive—resurrect a faint memory of the river that was.

In waters where steelhead trout once thrived, the fish now include domestic goldfish, dumped or flushed or escaped into the river and returned to the wild, the way that hundreds of parrots and parakeets have fled their cages over the years, and now fly in screeching Technicolor flocks over the sunset treetops of city and suburbs.

It was here, near Atwater, that the river once rolled up its sleeves in the city's breadbasket district, in the bakeries of Van de Kamp, Dolly Madison, Weber. Below, the river cleaves the working-class neighborhoods

Travel Town, Los Angeles

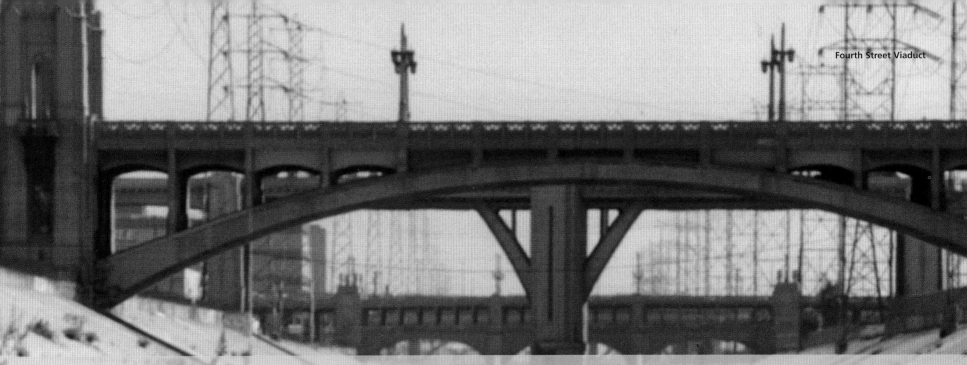

of the old city, where small stucco houses painted in the bright pastels of Hispanic *retablos* line the riverfront in cozy, neighborly barrios the locals still call Frogtown, for the creatures who croak there in a dwindling chorus, and Dogtown, for the dog pound built on the river's bank well before World War I.

Here, too, the river whisks away the waste from the official laboratory where the city of Los Angeles tests the efficiency claims of devices like low-flush toilets; in the public mind, the river is itself a kind of open-air self-flushing toilet.

The river makes its way through downtown Los Angeles, near the original pueblo, where the mestizo inheritors of the Indian village of Yangna still haunt the concrete riverbanks and paint its slopes with their own devices and ornaments, menacing and mystical by turns.

It crawls through the industrial gut of Los Angeles as little more than a chemical sump, and its very desolation invites the homeless and the hopeless to claim its meager water as their own, a parody of the suburbanite's backyard pool set in a concrete bezel.

The river that moves south across the working-class plains could have been laid out with a ruler. The soldered mass of towns along the

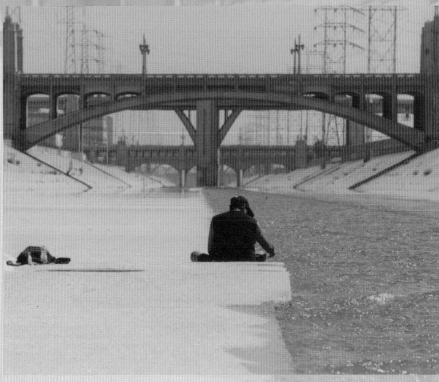

D. C. Tillman Water Reclamation Plant
Japanese Garden

lower river is more brown than black or white, and here the city fathers are heard to bless, with ample reason, the walls and levees that keep the river at bay, and want them built even higher and stronger.

Here the river's occasional waters are joined by other concrete tributaries, Rio Hondo, Compton Creek. It is flanked by shops and manufacturing plants and, dissonantly, the horse properties of Compton and north Long Beach, surprising green places and bridle trails amid the desolate efficiency.

At last the river disgorges itself and its accumulated debris from a throwaway city—enough junked furniture each year to fill ten houses, enough abandoned shopping carts to fit out a grocery store—into the harbor of Long Beach. Fresh water joins salt, swirling around four man-made islands named for dead American astronauts, islands where banana trees and carved tikis camouflage the ceaseless humping churn of oil rigs—a city of artifice to the last.

RICHARD BRAUTIGAN HAD to be thinking of the Los Angeles River when he wrote in *Trout Fishing in America* of wandering through a salvage yard and seeing a sign: "Used Trout Stream For Sale. Must Be Seen To Be Appreciated." The salesman directs him out back, where the stream lies cut up and stacked in piles of varying lengths, priced at six dollars and fifty cents a foot for the first hundred feet, and five dollars a foot after that.

If there were ever river gods in the waters of the Los Angeles, as there were in Greece, in Druid England, on the Nile, and if they have not deserted us as we have deserted them, they must be laughing at our folly.

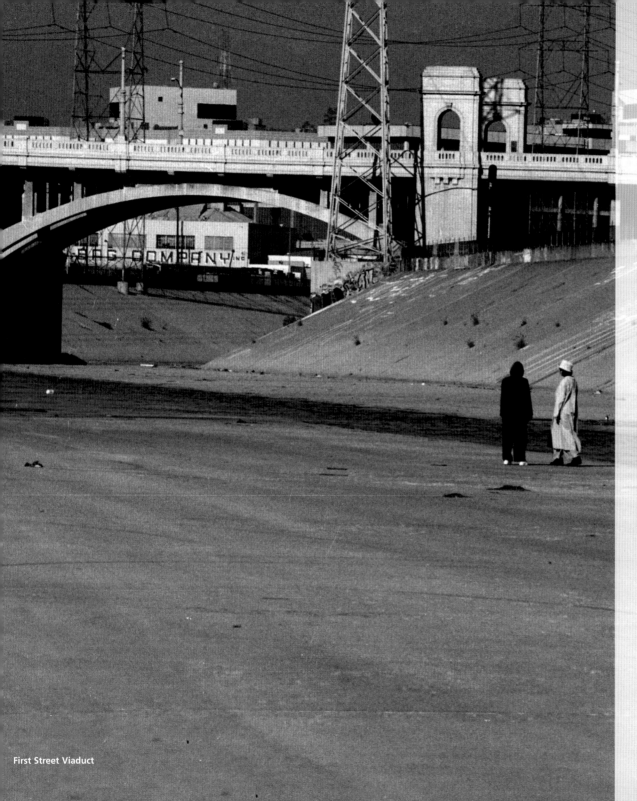

First Street Viaduct

To Artesia

I think of the river
The way it reads in the
Sam Shepard story,
Cruising Paradise—
A "huge concrete serpent,"
A "dumping ground for murder victims."
I think of the river beside a freeway off-ramp as
roller-bladers, bent into it,
spandexed buttocks rotating,
roll downstream. I think
of William Mulholland's
"gentle, limpid stream"
coursing from a Pharaoh's forehead
or from the brow of a Rhine-maiden,
green-eyed and coffee-colored,
a bracelet of drowned children
wrapped around her wrist, descending
from the mountains east of Irwindale
into the *jardin des rocas*. The river
is a rigorous mistress,
but when you tickle her
with your deeds, you can hear laughter from
beneath her concrete corset.

—LEWIS MACADAMS

Imagine Los Angeles

Bird's eye view of Los Angeles, 1888

as the face of a clock—

the mountains to the north at noon, the ocean at nine o'clock.

Now, think about this: virtually everything between six and nine o'clock, from San Pedro to Santa Monica—nearly four hundred square miles now encompassing the airport, the Los Angeles County Museum of Art, Paramount Studios and Watts Towers, Crenshaw Plaza and Rodeo Drive and almost every freeway that crosshatches Los Angeles—once lay within the reach of the waters of the Los Angeles River, and did, as late as 1825, when the nation's first railroad tracks were being laid.

The Los Angeles River, so docile today in its cement girdle, was once as wandering and restless as Woody Guthrie, the folk minstrel who roamed Depression America and wrote a song about the river's waters.

The river formed and shaped the landscape like a sculptor. The wetlands from Playa Vista to Newport Bay, the beaches from Santa Monica to Long Beach, were made and molded over ten thousand years by the currents and eddies of the Los Angeles River.

The river ambled across a Los Angeles that was unimaginably wetter than it is today—a terrain looking more like England than contemporary Southern California. In the river's broad reach, wetlands and woodlands thrived. Immense stands of sycamore and cottonwood and oak and alder stood like high-rises above tangles of willow and berry brambles and fields of grasses. Along the river's edge, wild roses and wild grapes grew fragrant and sweet. Decades ago, diggers turned up remnants of this Los Angeles, beneath where the spiffy high-tech downtown jail now stands—a buried and vanished forest ten feet below the slammer.

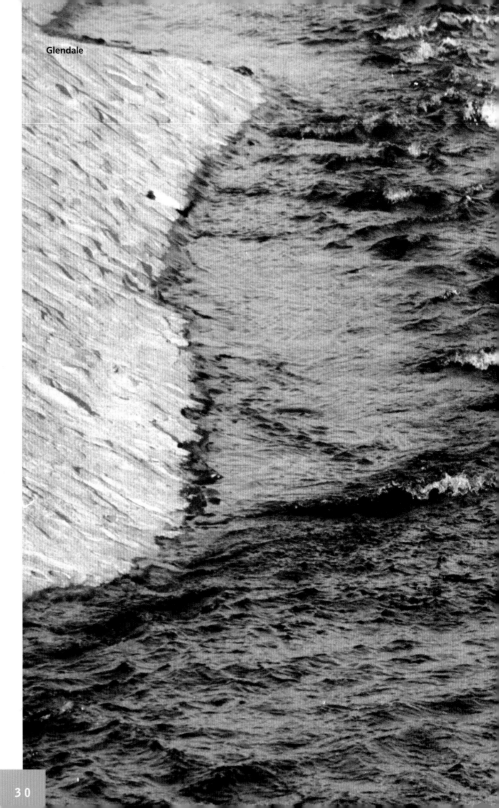

THERE WAS A TIME WHEN THE EARTH ON WHICH LOS ANGELES stood seemed, like the human body, to be made up mostly of water—pools and marshes and bogs of it. If the comparison to England sounds farfetched, get this: beneath some surf cities of the coast lay peat bogs.

Small springs and freshets sparkled across the landscape, down hillsides in Elysian Park and Los Feliz. The waters of the *Arroyo de la Zacatera* ran from Silver Lake down through Hollywood to marshes below Baldwin Hills before joining Ballona Creek on its way to the wetlands between El Segundo and Playa del Rey.

In 1769, the day after they "discovered" the Los Angeles River— remember, this was in the heat of August—Spanish explorers came across *El ojo de agua de los Alisos de San Esteban*, the spring of St. Stephen's sycamores, below the hem of the Hollywood Hills. They trudged through summer swamps, *cienegas*, now La Cienega, the chic boulevard where money flows like water and water flows only from bottles. The original Spanish name for the ranch land where Beverly Hills would one day swish its elegant skirts was *Rodeo de las Aguas*, meeting of the waters.

There was so much water—a great deal of it underground, as the bulk of an iceberg lies beneath the ocean's surface—that centuries later, real estate hawkers weren't altogether lying when they told potential in places from Toluca Lake to Downey that they would only have to dig, and water would leap forth as it did when Moses struck a rock with his staff.

It wasn't rainfall that made this plain green and lush, but the river,

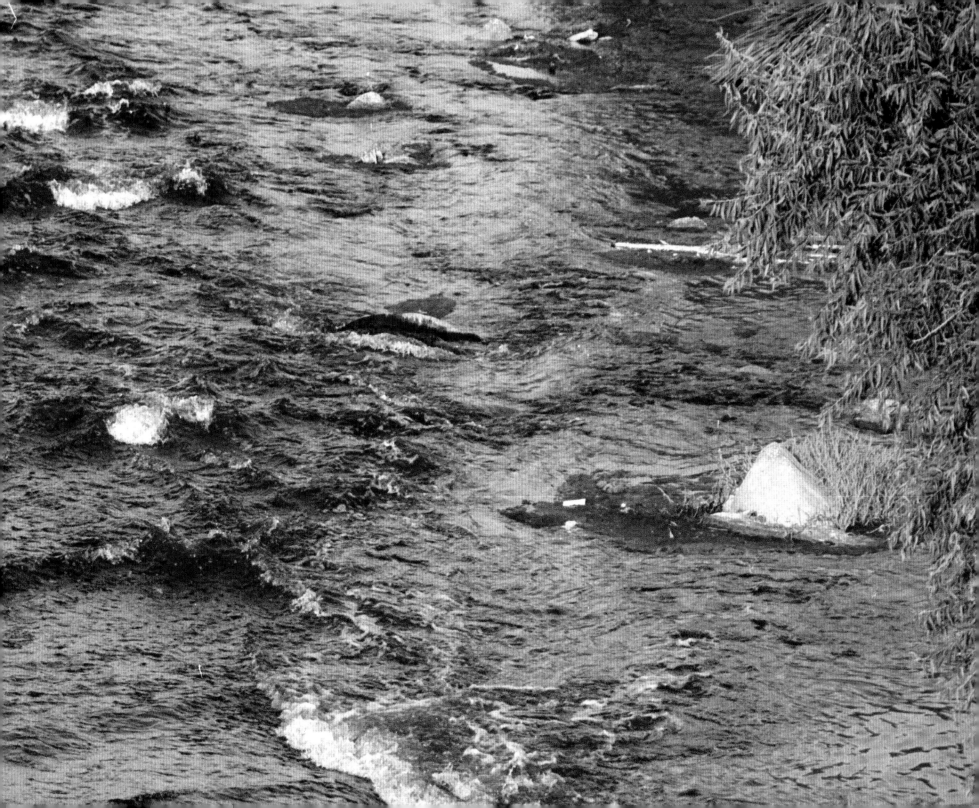

Los Angeles Equestrian Center, Burbank

Compton

spilling down from northeast and northwest onto the long, flat miles of the Los Angeles basin, where it made itself into a braided lacework of waterways.

The river was born anew each year when storms of Old Testament proportions walloped the steep slopes of the Verdugos and the San Gabriels. It raced the wind downhill, along Verdugo Wash and the Tujunga Wash and the Arroyo Seco and myriad nameless canyon channels. It joined the gentler flows from the San Fernando Valley, where the backside of the Santa Monica Mountains and the sloping land below the Santa Susanas form a V-for-valley funnel to the river.

In the San Fernando Valley, the river now creeps timidly in its cement corset for some distance between a freeway and a boulevard named Ventura, but it makes its presence known. The land still sends the water flowing faithfully toward the river as it has for thousands of years, and in the underground garages of swanky buildings on Ventura Boulevard, the sump-pumps work night and day, night and day, to keep the ancient river at bay, away from the Mercedes-Benzes and BMWs.

The Los Angeles River never was a river as the Seine or the Thames is a river. It was unlike any river the Europeans had ever seen. It swelled and shrank by seasons, spawning small streams that lasted only as long as the water did. And instead of tumbling and roaring in solitary majesty

into the Pacific Ocean, the river petered out into marshes and wetlands.

The Indians' language recognized the lands' and waters' two seasons—either "it is full of water," or, in the dry months, "the water has departed." Later Yankee wits would split Los Angeles' seasons between "flood" and "flea."

No more is left of this wet Los Angeles than small struggling patches of water, damp shadows like Machado Lake, a leftover of the Pleistocene ecosystem surviving in a park in Wilmington and Harbor City, near San Pedro. People are hard-pressed to think of these spots as any less artificial than a hot tub. When an odd-looking bloom spread over the waters of Machado Lake in 1990, the park authorities fretfully called in the toxic testers. Was it paint? Heavy metals?

The strange, alarming stuff was algae.

WITH THE WATERS CAME THE CREATURES, leaping and creeping things, and the beasts with teeth that fed on them. The Spaniards who first happened upon the river in 1769 shot an antelope and barbecued it that night. The original review of Los Angeles cuisine, by the expedition's priest, Father Juan Crespi, was this modest assessment: "It was not bad."

More than a hundred varieties of birds—the California condor among them—coursed the river for food and breeding places. For California grizzly bears, the river was an all-you-can-eat

smorgasbord of steelhead trout. Today's timid suburbanite calls 911 when he sees a vegetarian black bear snuffling around the trash cans. The carnivorous ursines who once foraged here were big as bulls, with claws like steak-knives and a roar like an earthquake. The California grizzly exists now only on the state flag; the last one was shot by a rancher in 1922.

By the twentieth century, when the river had been paved into irrelevancy, the very notion of living things in it made amusing newspaper copy; imagine—fish, in that.

Civic memory quickly abandoned the river as a living place, but nature's memory did not. Even today, where the river and its tributaries are not concreted, like Big Tujunga Wash, the Sepulveda Basin and the Glendale narrows, an obviously hardy range of plants and birds manages to survive.

On the riverbank where the Arroyo Seco empties its occasional waters into the Los Angeles River stands the once-notorious Lincoln

Heights jail, the original "Graybar Hotel." There, in 1951, the second act of the Bloody Christmas jailhouse beatings took place, the police scandal that became the underlying plot in the film *L.A. Confidential*.

The river's-edge jail has long since been exorcised. Moviemakers love to film in its grime-and-crime vérité. And the producer of the movie *Grease*—those drag-racing moments were shot in the Los Angeles riverbed—once threw a black-tie party at the jail for writer and bon vivant Truman Capote.

The jail backs onto the river, and one winter in the 1930s, a jail trusty, an Indian named Greyfox, heard splashing and looked down to see fish in the river. He stepped into the water and hauled out a two-foot steelhead trout that weighed in at six and a half pounds on the jail's kitchen scale.

Two men looking for crayfish in November 1937 scooped out a three-pound bass with a butterfly net. A couple bicycling along the

riverbed on a March morning in 1941 waded in after a big steelhead, snagged it with their bare hands, and cycled home to fry it for breakfast. In 1965, a five-year-old boy hauled out a ten-pound carp and sold it to a neighbor for two dollars and fifty cents.

It was against the law to catch steelhead in January and February, when they came upriver to spawn, but by World War II that was like outlawing unicorn-hunting. There just weren't any to catch.

FROM TIME OUT OF MIND the river and its petticoat streams flowed more or less west and southwest and south, to Santa Monica Bay and Ballona Creek for a while, then down to Marina del Rey and San Pedro Bay.

But the apocalypse rains of 1825 altered the river and the Los Angeles landscape forever. It rained for days—eight, ten, the numbers grew with each retelling. The water came chuting down off the hills and into the riverbed, blowing out the confines of the old waterway. It stampeded past Boyle Heights, ripping away earth and stone to leave tall white cliffs in its wake, a miniature Dover that the locals took to calling *Paredón Blanco*, the Big White Wall.

The water washed through the old pueblo, melting the adobes like sugar cubes. It had enough strength and water to spread east, where it climbed into the bed of its sister river, the San Gabriel. And then, when the water reached the place where the University of Southern California now stands, it didn't make its usual ninety-degree turn and head more or less west, as it had over the centuries. Instead, it bulled its way south, scouring a new path to the sea, to San Pedro Bay. And there the river would stay.

Without the western spread of waters, the Los Angeles basin changed, swiftly and radically. Within a single human lifetime, the forests and undergrowth—once so beautiful that Kit Carson was moved to call Los Angeles "truly a paradise on earth," once so dense that a squirrel could probably have journeyed from the Los Angeles Coliseum to Westwood without ever touching ground—dried up and died.

And only the river remained.

Long Beach

Before Los Angeles,

Atwater Village

there was Yangna.

As downtown L.A. is to its suburbs, Yangna was to the smaller Indian villages set along the river—a civic center.

Now, *Kawengna*—we say Cahuenga—is a delightful word meaning "place of the mountain." And *Topangna*, simplified to Topanga, means "place where mountains run out into the sea."

Yangna means roughly "salty" or "alkali-tasting." Perhaps it was a comment on the flavor of river water. But like all prime real estate, Yangna had three advantages: location, location, location. It stood centrally, near the river, and close by the Council Tree.

The Council Tree was a massive sycamore six stories tall, and under its branches, the chiefs of the villages met and conferred. It was a sapling when Cortez conquered Mexico, and it would outlast the Indians it sheltered, but not by long. When the great flood of 1835 had passed, a boy remembered looking out over the ravaged landscape and seeing only the Council Tree left standing. Before the century ended, the Council Tree was dead. The city chopped it down and sold it for firewood.

Yangna was the chief village, and the chief god to the tens of thousands of Gabrieleños was Chinigchinich, giver of laws, ruler of earth and sky and maker of both. He was born in the village of Puvunga, which stood between the Los Angeles and San Gabriel Rivers in Long Beach, perhaps on the grounds of what is now California State University, Long Beach; it is one of three archaeological sites in all of Los Angeles County to appear on the National Register of Historic Places.

If these Indians called themselves anything—and some say they didn't bother—it was probably Tongva. To the Spanish, they were all wards of the San Gabriel Mission, and so Gabrieleños they became.

Where Yangna had stood, no one quite knew, in part because it was a movable village according to the seasons, and also because fifty years after the Spanish arrived, no one troubled himself overmuch about the Indians.

But some men digging elevator shafts late in the twentieth century unearthed relics from a Gabrieleño settlement founded a thousand years before Christ—just a couple of blocks north of the 101 freeway in downtown Los Angeles.

As the modern city depends on the freeway, the ancient one depended on the river. The water fed the creatures that fed the Gabrieleño—trout, blackbirds, rabbits, snakes, grasshoppers — and the creatures they revered, like the hawk. In its shallows grew the brush to build huts and sweat lodges—*temescals*, where warriors purified themselves. From those shallows also came the nettles the hunters slapped their bodies with before the hunt, to sting themselves into alertness, to bring down the deer, whose hides made winter wraps and whose leg bones made trilling flutes.

When the brush *wikieups* got ratty or vermin-infested, they were burned and new ones built. The Gabrieleños called the river *otcho'o*, or *pa-hyt*, or *wenoot*, and regarded it with wary reverence, and sometimes buried charmstones to fend off floods. Even so, the river waters could come thundering down and swirl away the huts like teacups spinning in the Mad Hatter's ride.

THE SPANIARDS WERE LESS CAUTIOUS about where they built, less mindful of the river's lessons, and the Indians must have been amused when floods crumbled the adobes of the fledgling pueblo. The cornerstone laid in 1814 for La Placita, the city's first church, which stands opposite Olvera Street today, had to be moved to higher ground when the flood of 1815 left it underwater.

In the ways of the river and the land, the Gabrieleños were an advanced civilization. For medicine they used the bark of the river willow; in 1899, a German chemist would treat his father's arthritis with a willow compound and "discover" aspirin. Their shamans brewed *toloache* from

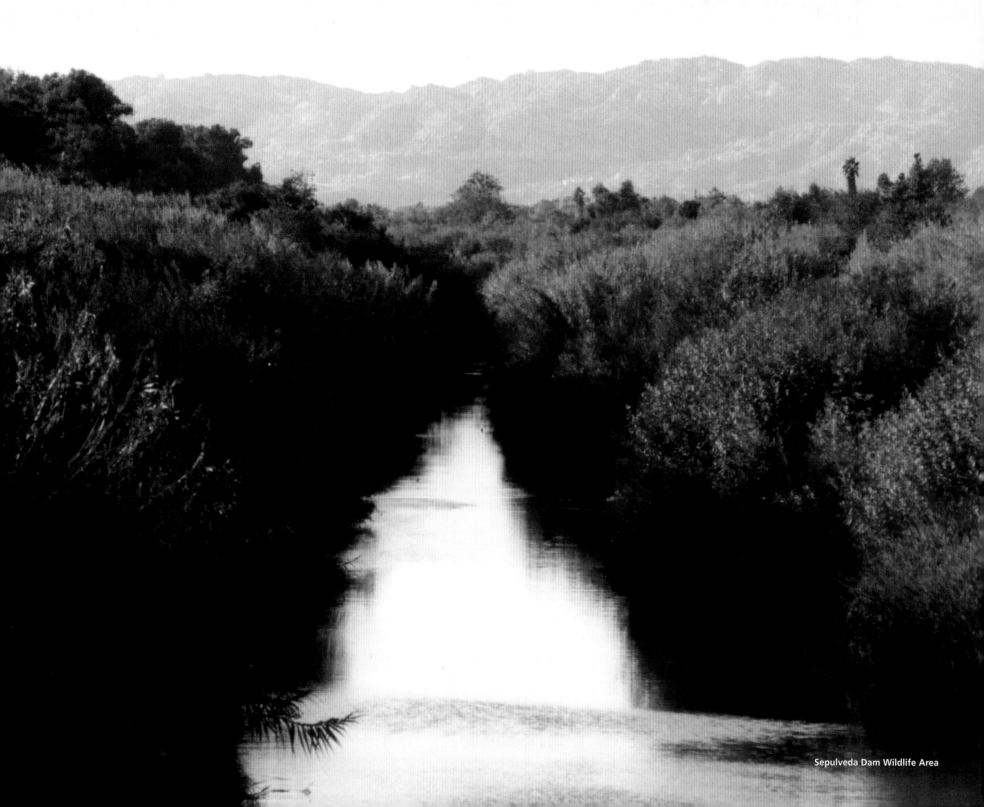

Sepulveda Dam Wildlife Area

datura, a kind of jimson weed. A young man drank it to embark on the hallucinatory journey to find the sign that would guide him through his days. The datura, with its extravagant trumpet blossoms, still defies Yankee know-how, and works its stubborn way through the concrete batter that has been spread over the riverbanks, to bloom white and fragrant in the light of the old Gabrieleño moon.

The women wove baskets from the river's tule reeds. To carry water, they coated their baskets with *brea*, tar from the bubbling black springs. Gabrieleño baskets were always prized as trade goods. The emperor of Japan possesses one of these ancient river-reed baskets, a gift from the city of Los Angeles.

So these Shoshonean people had lived for six or seven thousand years, until the day—it was a Wednesday, August 2, 1769—that the Spanish came crashing out of the brush and thickets to the east.

They had broken a trail from the San Gabriel Valley, and came upon "a good-sized, full flowing" river about twenty feet across. Eight Indians approached from "a good-sized village encamped at this pleasing spot among some trees." The strings of their bows were deliberately removed in a gesture of peace. The Indians passed around baskets of sage tea for everyone to sip.

For a brief time, the Indians would regard the Spaniards as gods— after all, they could make fire from a stone and light their pipes. Then a soldier casually felled a bird with a musket ball. Any child knew that gods only give life, they do not take it. So the Spanish were human, after all— and rather unprepossessing and smelly ones, too, to the noses of the Gabrieleños.

The Spaniards' arrival coincided with a swarm of summer earthquakes. The Gabrieleño world rested on the shoulders of seven

giants, and when the earth shuddered, it meant the giants were restless and uneasy.

It was as good—or as bad—an omen as any.

IN YEARS TO COME, some Gabrieleños would make a practice of accepting Spanish trinkets but throwing away Spanish food. When cornstalks sprouted where Indian boys had tossed a few kernels, the shamans declared it "white witchcraft." Spanish candy was "excrement." Children born to women who had been taken by Spanish soldiers were sometimes quietly strangled and buried.

The missions and the juggernaut of modernity eventually conquered the Gabrieleño, but they did not go meekly. One of many revolts, this one in 1785, was led by a shaman and the daughter of a shaman, a woman named Toypurina, who was indignant at the devastation of her people.

Her rebellion against the San Gabriel Mission recruited a score of warriors, but someone tipped off the Spanish, and almost all of the Indians were captured. Toypurina feared the Spaniards' vengeance on her followers and agreed to convert. Her Indian marriage was annulled. She was exiled to Monterey. There, she married a Spanish soldier and bore four children. She died in 1799, the same year that another who had fought for his country also died—George Washington.

The "free" Gabrieleños of the twin towns of Yangna and Los Angeles became the labor pool for the pueblo. Yangna was at least a thousand years old, but a Gabrieleño born the year the Spanish pueblo was founded, in 1781, would have lived to see the last of Yangna. In 1836, the two hundred or so surviving Indian townspeople, who had once foraged in the river valley, were herded onto a triangle of riverside land downtown. Its sides were shorter than a football field's.

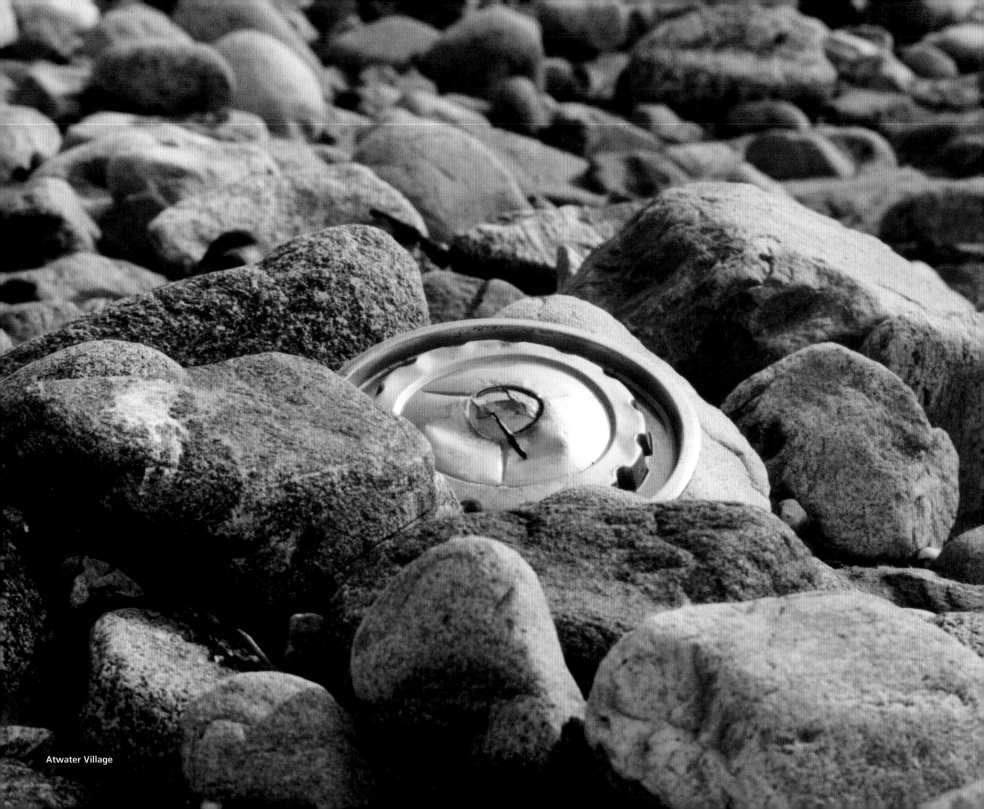

Atwater Village

Ten years later, Los Angeles moved them again, across to the east bank of the river. A new generation of soldiers—Americans, full of bravado at the coming Yankee tide—began gambling and whoring among the Indians. In 1847, Los Angeles used what authorities called "disorderly gatherings" as an excuse to rid itself of the last vestige of Indian land.

The huts were burned. Charitably minded townsfolk collected twenty-four dollars for the newly homeless Indians, the exact value of the trade goods that effected the transfer of Manhattan from red hands to white.

Americans would complete what the Spanish had begun. Indians found without government passes were "treated as horse-thieves and enemies," complained C.E. Kelsey, the federal agent for California Indians, who came long after Yangna had vanished.

Drunken Gabrieleños were rounded up on Saturday nights and penned in jail or in open corrals until Monday, when their services were auctioned at the jail gates. Sometimes they were set to work digging the irrigation ditches, the *zanjas*, into which flowed the waters of the Los Angeles River.

Early in the twentieth century, a historian listening to an old man speak wrote down some of the last words uttered in the Shoshonean dialect by a native Tongva speaker, words that were an obituary for a people and for the river their grandsires had known:

Wikumimuk taraxat we. When Indians died, the villages ended. We, all the people, ended.

To distinguish themselves from

Long Beach Harbor

the natives, the pagans,

the Spanish conquerors of Southern California, foot-soldiers to bishops, called themselves *gente de razón*, the rational people.

Rational people who want to settle a place look first for water, and for this reason they chose the same river where the pagans lived.

Trudging up from the parched fastnesses of Mexico, they had been delighted at the first glimpse of this "full flowing wide river." It wasn't as broad as the two rivers that the expedition had forded a few days earlier, the San Gabriel and the Santa Ana, but Father Crespi believed fulsomely that "this bears away the prize."

By happenstance the Spanish had found the one spot on the long tangled river that flowed year-round, a stretch above present-day downtown Los Angeles called "the gap" or "the narrows," where geography and geology conspire to keep the water flowing. Any distance above or below there, and the river was pretty much a part-time proposition, as many western rivers are.

Edward Ord, who mapped Los Angeles a dozen years before the Civil War—and named one of its streets Primavera, or Spring, as a compliment to his lady-love—dined one evening with the friars of the Santa Barbara mission. Swirling in his glass some seven-year-old wine from mission vines, he amused himself by recounting tales of the great and constant Niagara River.

"*Todo el año*, all the year round does it run?" the padres asked in wonderment. "Oh yes," Ord assured them. "It never dries up."

THE SPANIARDS REGARDED THE RIVER as they regarded the Indians—something in need of civilizing. The priest who chronicled the trip assessed the

the settlers on it. The Spanish wasted little time making use of the Porciúncula. On a September morning in 1781, eleven families brought up from Mexico to populate the alien land—a twelfth family had defected en route—walked with soldiers and priests from the San Gabriel Mission to become neighbors of Yangna. Of the forty-four men, women and children, all but two were a mix of Indian, black, and Spanish blood. None of them could read or write.

Among the items that the king of Spain was good enough to give to each family were a spade and a hoe. With these they dug the first *zanjas*, the water ditches from the river, the system on which Los Angeles would depend for a dozen decades. The biggest was the *zanja madre*, the mother ditch, the lifeline from the river to the town.

The Porciúncula's waters made the little outpost verdant beyond fantasy. By 1800 Los Angeles was growing enough grain to send sacks of it back to the Mexican motherland—just as, one hundred fifty years later, Los Angeles would be feeding the nation as the most fertile agricultural county in the United States. Decades before Napa stomped a single Sauvignon grape, scores of Los Angeles vineyards and vintners were turning out millions of gallons of wines—all with river water.

From the hills of the South Bay, travelers looking eagerly across

river valley as shrewdly as any twentieth-century real estate developer.

The river ran with "pure and fresh" water, Father Crespi wrote, its "large, very green bottomlands" looking "like nothing so much as large cornfields . . . a most beautiful garden. Good, better than good . . . to my mind this spot can be given the preference in everything, in soil, water and trees, for the purpose of becoming in time a very large plenteous mission." The Spanish, in other words, had opened escrow on Los Angeles.

Spanish settlements in the New World, like Roman camps in the old, were about as prefab as a McDonald's: a public square, houses around the square, and fields and pastures beyond those. You worked, or you left. The land belonged to the king of Spain, and so, for ten years, did

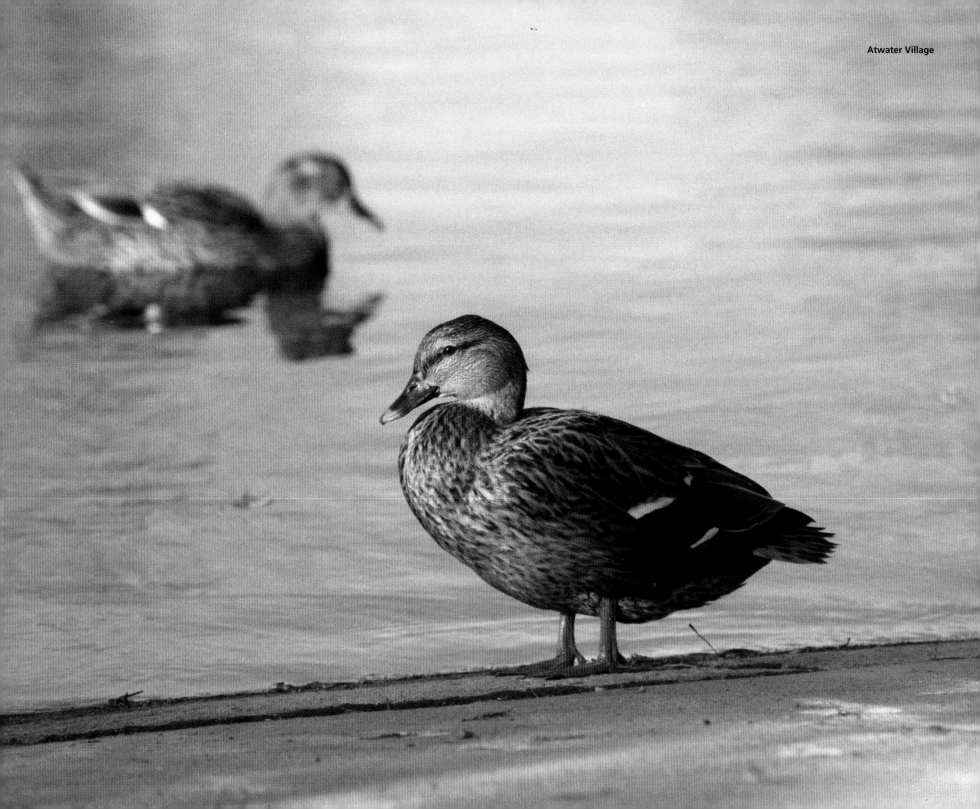

Macy Street Viaduct

Elysian Park

Compton

the dusty plain to the north could see "a thin line of green some fifteen miles off"—the cornfields and vineyards and groves along the river.

It was a multipurpose river—irrigating, bathing, drinking. Instead of dipping their pots into the common ditch, wealthier and more fastidious Angelenos could opt for home delivery, an eighteenth- and early nineteenth-century Sparkletts service. As the street peddlers of London sang out their wares, the Indians of Los Angeles walked the unpaved streets bearing Dutch-milkmaid yokes on their shoulders with clay pots of water, crying ¡Agua! ¡Agua! ¡Agua!

WARS WOULD CHANGE CALIFORNIA from Spanish to Mexican to Yankee hands, and two battles of those wars were fought along the banks of the Porciúncula.

Mexico first fought Spain for its independence, a war that unsettled Californians very little. They just hauled down one flag and ran up another.

Then the *Californios*, white and brown, battled Mexico for their independence. It was flood season, February 20, 1845, when Mexican soldiers and *Californios* faced off across the river, near where Coldwater Canyon now crosses Ventura Boulevard.

A man named Henry K. Norton recounted it as if it were no more consequential than a paintball fight: three Mexican cannons against two *Californio* cannons, amateur soldiers hunkered down under the riverbanks. The only casualty of the fray was a Mexican horse. The *Californios* won, Norton suggested, because the Yankees "had got together the night before and enjoyed an old-fashioned 'bust' down in the willows by the river" and voted to side with them.

Not quite two years later, the *Californios* fought one last battle, this one against the Yankees and their Bear Flag Republic of California. This battle looked more like real warfare. On January 9, 1847, near the pueblo's riverside stockyards, where the slaughterhouses of Vernon now stand, rows of saber-swinging *Californio* cavalrymen charged the Yankees, who knelt and fired and reloaded and fired again in orderly ranks.

The next day, William Workman, a Yankee in sympathy with the mostly Hispanic *Californios*, bore the white flag of surrender into the pueblo, and the "dear City of Angels" was a Yankee city, its river a Yankee river.

Once Los Angeles had
become a Yankee town,

Vernon

it wanted a Yankee river.

For starters, who could pronounce *Porciúncula*? *Los Angeles* was enough of a tongue-twister. The Los Angeles River it would be.

And where *Californios* had been content to let cattle graze and to plant watermelons and grapes enough for their haciendas, these new Angelenos surveyed the land with calculating Calvinist utility. What good was a lazy river that couldn't turn a paddlewheel or float a barge of goods?

So the river acquired a character to match its new masters. In short order, river water was powering flour and woolen mills, and making castor oil out of the beans that grew wild along the river. The Los Angeles Brewing Company, ancestor of Eastside Beer and Brew 102, got its brewing water from buckets dunked in the river that ran past.

The river supplied the first public bathhouse, turning a small waterwheel fitted out with tin cans that dipped into the water ditch as the wheel spun. The enterprise was owned by the city treasurer, who charged fifty cents a bath, hot or cold, soap and towels included. The presses of the *Los Angeles Times* were once driven by river water, and now and then the newspaper's future publisher, Harry Chandler—this was before he married the boss's daughter—had to stop the presses and go fishing around for the occasional trout that had slipped in and clogged up the works.

THE *ZANJAS* THAT HAD suited the Spanish and Mexican pueblo cramped the Yankees' ambitions. *Zanja* construction went into overdrive, as freeway construction would a hundred years later. The *zanjas* made many rivers out of one. Ditches were laid as far east as Boyle Heights, and as far west as today's Pico-Union, north and south from the current site of Dodger Stadium to where the University of Southern California now stands. Stretched out like cable, the *zanjas* would have reached from Santa Monica to the San Bernardino county line.

Living any distance from a *zanja* was like living on the moon. Before the *zanja* got to Boyle Heights, land there sold for twenty-five cents an acre, and a man who tried to sell his at any price got no offers.

Murder and rough justice were committed in the name of water.

A homicidal Frenchman named Michel Lachenais had already killed a fellow Frenchman at a wake for a mutual friend. In 1879, he shot and killed a man named Jacob Bell in a feud over water for eighty acres of land near Exposition Park. He was promptly lynched and hanged at the corner of Temple and Spring Streets, the future site of the courthouse where O.J. Simpson was tried for murder.

From the Indians who had peddled water door to door, Bill the Waterman took over, a massively mustachioed man in high-top waders. For fifty cents a week, he added you to his rounds, stopping with his two-horse cart and his sixty-gallon barrel to deliver a bucket a day, every day but Sundays. If you preferred, he emptied his bucket into your *olla*, the earthen jar hanging on your front porch with a gourd dipper hooked to its lip.

If you lived near a *zanja*, it was your refrigerator; you kept your meat fresh in a bucket nestled in the rocks at the water's edge. Frugally, you used your leftover bath water to irrigate your garden. The schoolmaster stirred up a scandal in 1855 when he used drinking water on the black locust trees planted on the school ground.

Any stream is an irresistible playground. In the fall of 1886, a huffy letter to the *Los Angeles Times* scolded "the parents of some fifteen to twenty boys and girls" who dawdled along the river, "playing Hoodlum in the Willows," committing unspecified "profanity and obscenity."

A generation earlier, one of those loitering boys was a future sheriff, Martin Aguirre, who dammed up a bit of the river for a swimming hole, lined the bottom in stinging nettles and then invited his friends to jump in. The predictable results: more "profanity and obscenity."

Generations after Aguirre's boyhood, the Watson brothers, a long family line of Los Angeles news photographers who also filled boys' roles in such movies as *Heidi* and *Mr. Smith Goes to Washington*, went swimming on hot days in the river near Atwater, sans swimming trunks. Aboard the streetcar that shuttled across the old wooden bridge, the passengers knew to lean out and wave at the buck-naked little boys below.

Jack Kunitomi was born and grew up near the west bank of the river—"one of our playgrounds" for the local boys in the decade before the Depression. In the summer, he and his buddies dammed it for shallow

Near Imperial Highway, 1951

pools to practice racing dives, and the rest of the year they went netting butterflies for school science projects. Decades later, Kunitomi remembered the day he and his friends were routed from the river by the Russian kids who lived on the east bank, in "the Flats." They descended whirling slings bearing stones, "like David slew Goliath with," pelting the west bank boys into retreat. Later, Kunitomi and his friends went back to the water—but with firepower, an older boy with a BB gun who sat watchfully on the bank, "so we kind of regained the rights to the river." Nearly seventy years later, there is still a triumphant little chuckle in Kunitomi's voice at the remembering of it.

In 1853 drunken vigilantes staged a mock trial and found the town marshal guilty of "skulduggery." They tied a rope around him and dragged him up and down the *zanja*. When he failed to drown, they all gave up and staggered home.

The city fire department, which now operates swift-water rescues on the river, in the nineteenth century had the job of removing the corpses of "Chinamen, Indians or animals from the *zanja*." A fireman who lasted five years on the force earned his exemption from that duty, and the Exempt Firemen's Association was organized to remind everyone of the fact.

Who knew where that water had been, anyway? People washed in the river, animals waded in it, and the *zanjas* were open to any contamination. Dysentery was as common as a cold. Summer was fever season, when the river flowed low and slow. Smallpox epidemics sent the Black Maria wagon out to cart off the victims. When children living on South Figueroa Boulevard came down with diphtheria in the winter of 1899, their families demanded that the city close the neighborhood *zanjas* and put in water pipes instead.

LIKE THE TIBER, where Romans tossed the bodies of slaughtered enemies, like the Ganges, carrying away the ashes of the dead, the Los Angeles River was expected to be more than mere water.

The steaming, stinking city dump rose on its banks in the nineteenth century, and to this day, the river is still treated like a conveyor belt

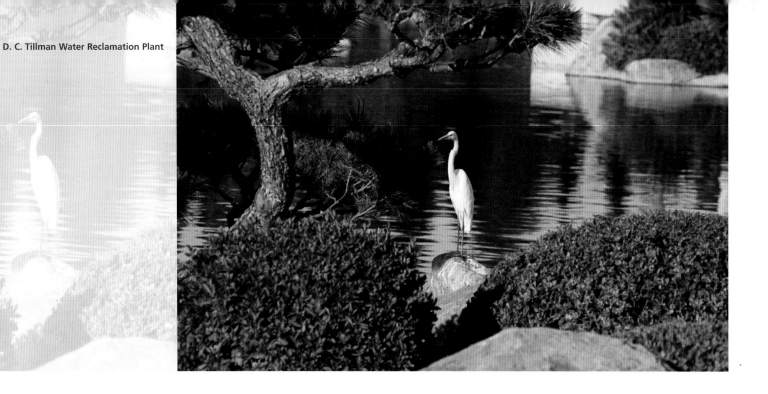

D. C. Tillman Water Reclamation Plant

for garbage. Don't want it? Dump it—from the carcasses of eighty horses and mules killed in a fire at the Covarrubias' stable in 1887, to a blue velvet ottoman floating downstream a hundred or so years later. The river, pontificated a *Los Angeles Times* letter-writer in 1889, is "the natural and proper outlet for the sewage of Los Angeles city."

For two hundred years, the river has muscled away the leftovers of living: from Chanel No. 5 to chromium 6, from the dung of million-dollar racehorses at the Santa Anita racetrack hosed down one of its tributaries, to chemicals so potent they could have eaten right through the cement.

The ignorant and incurious who now inhabit the city think the thousands of storm drains along the curbs are handy street-level trash slots, and dump unspeakable things into them, animal, vegetable and mineral. Each year, eight thousand tons of trash—"floatables" in the cleanup-trade lingo—must be skimmed off the water at the river's mouth, to the perpetual annoyance of the city of Long Beach. In those tons of predictable urban junk and the household goods of the homeless,

perplexing and outlandish oddities have been dredged out, such as a prosthetic limb, a skull, a hot tub, and a Santeria sword.

As often as Angelenos let the river do their dirty work, they were begged not to. An 1852 edict commanded that clothes be washed only along a certain *zanja* at the peril of a three-dollar fine, but the law was flouted then as often as speed limits are today. "From sunrise till evening," the *Los Angeles Star* groused in 1855, "groups of females from 'snowy white to sooty' can be seen at the daily avocations of washing clothes through nearly the entire length of our water canals."

Ninety-nine years later, the city was still begging its womenfolk not to foul the river. In January 1954, drains were backing up and the sewers were overflowing into the rainy river. The city fathers took desperate measures: they divided the San Fernando Valley into six districts, one for each day from Monday through Saturday. Housewives, who then still observed the Monday washday tradition that goes back to the Pilgrims' landing at Plymouth rock, were ordered to do their laundry only on the

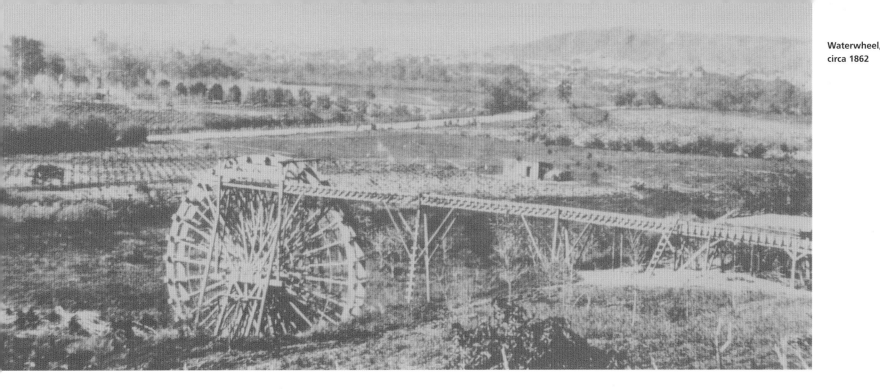

day of the week designated for their district. Like the "snowy white to sooty" laundresses before them, there is no evidence the housewives of the San Fernando Valley paid any attention.

THE GOLDILOCKS NATURE OF THE RIVER—too wet, too dry, just right—demanded that somebody do something.

Among the earliest somebodies was William Dryden. He set up the first of the city's several waterwheels in 1857, a rickety Rube Goldberg contraption near modern-day Chinatown. When that one flooded out in 1862, another entrepreneur imported a forty-foot-diameter wheel from San Francisco and raised it up on the river in Elysian Park. It looked like a Ferris wheel, but instead of seats, fifteen-gallon barrels scooped water onto a flume, which flowed into a reservoir on the plaza, where wooden pipes sped it to customers.

At least that's how it was supposed to work. In reality, the waterwheel washed away in a flood, and the first pipes the city laid

were hollowed-out pine logs that were always bursting at the joins and turning the streets into sinkholes. Jokesters put up skull-and-crossbones signs at especially sodden intersections.

One partner in the pine-log enterprise couldn't bear the disgrace. Damien Marchessault was a French-Canadian who had a career as a professional gambler in New Orleans before coming west.

He must have had a gambling man's charm, and a gambling man's fondness for risk. Five times he was elected mayor of Los Angeles. Then he was made water overseer. He held that title the morning of January 20, 1868, when he slipped into the empty city council chamber and shot himself. The note on the table near his body begged his wife's forgiveness for the business debts, the drinking and the gambling, and for this, his suicide: "I am now ashamed to meet my fellow man on the street."

Six months later to the day, the city itself committed a kind of suicide. Frustrated with all the failures, it washed its hands of the matter, and leased out Los Angeles' water rights for thirty years to a private

company. It would have sold the water system outright, but the mayor vetoed that. The next three decades were a succession of the rich and powerful trying to get richer and more powerful on river water.

In that thirty years, elaborate plans and sometimes even elaborate water systems were laid. Conduits were put in, dams were put up. Echo Park Lake, with its present-day fountains and bridges and lotuses, was originally nothing more picturesque than city reservoir number four, its waters stored up behind a dirt dam.

By the end of the Gay Nineties, the county's population was closing in on 170,000, and people had begun grumbling about a "water company ring." The thirty-year lease expired in 1898, but the water cabal resisted. It took four years of sweet talk and sharp dealing and million-dollar payouts before the city owned its river water once more.

Los Angeles never gave it up again.

The saying in the west is that whiskey's for drinking, and water's for fighting over. For two hundred years, the city has fought it out in court over rights to the river's water, above ground and below.

It fought the padres of the San Fernando mission nearly two centuries ago when they dammed the river at North Hollywood. It fought the cities of San Fernando, Glendale and Burbank in the twentieth century, in a case that dragged on for twenty-three years, three months and twenty-seven days. The San Fernando Valley secession movement will probably send water litigators into court again in the twenty-first century.

Each time, a judge has ruled that the 1781 declaration by the Spanish king, Carlos III, still holds: it is the city's water, and the city's alone.

What makes this so droll is that the Yankee officialdom insisting on the legality of a water edict from the Spanish throne is the successor to the same one that ignored the legality of land grants given to Spanish and Mexican families by the same Spanish throne, and looked the other way when *Californio* families were done out of their land as slickly as the Indians had been tossed off theirs.

EVEN ONE OF THE MOST EFFUSIVE CHRONICLERS ever to put pen to paper on the subject of Los Angeles, John McGroarty, had to admit: "It was only when the gringo came and insisted on making a city where it seemed that neither God nor man ever intended a city should be, that the problem of water became momentous."

The stampede of Easterners and Midwesterners moving to Los Angeles in the 1880s shoved crops out of the city limits to make room for neighborhoods. The cycle picked up speed like a waterwheel in flood season: more people needed more water, and the river was less able to quench their thirst. Wells and windmills began to ornament the flatlands, pulling water up from the earth where the river's reach had refilled it. In time, in many places, that underground source would be tapped out.

The relentless sunshine blinded boosters and newcomers alike to Los Angeles' other four seasons: flood, fire, quake and drought. "Imaginative" is the kindest term for the come-ons. In the same spirit that real estate hucksters stuck oranges on Joshua trees and called them citrus groves, advertisements showed paddle-wheel boats making their leisurely



the *zanjero* to buy permits to divert river water into their fields, for so many hours, at a set price per hour. Naturally this led to mischief. Whites raged that Chinese gardeners (whose vegetables were incidentally the best on the market) were cutting into the *zanja* at night, then sealing it up again before dawn. If the Chinese were water thieves, they were not alone.

The most famous *zanjero* of them all lived in a shack near the river, opposite the entrance to Griffith Park, at the corner of Riverside Drive and Los Feliz Boulevard, where a fountain named for him now stands. (During the drought of the 1980s, the fountain stayed virtuously dry.)

William Mulholland first glimpsed the Los Angeles River almost a century after Father Crespi did, and he shared the padre's delight in the "beautiful, limpid little stream with willows on its banks. It was so attractive to me that it at once became something about which my whole scheme of life was woven. I loved it so much."

From his roots as a lowly ditch-digger, Mulholland became, in 1902, the city's water czar. The river that had enchanted him could not stand up to the visions of the men who had ambitions—and land holdings—far beyond the reach of the river's water. They wanted a city that could outgrow its river.

In time, Mulholland gave them a means of having it. He dug the biggest Mother Ditch of all, an artificial river, the stupendously engineered 233-mile aqueduct from the Owens Valley to Los Angeles, which to this day, provides nearly four ounces of every cup of water that flows from the taps of the city of Los Angeles. A bit over three ounces in that cup comes from the Colorado River aqueduct, and only a splash over an ounce comes from the wells that still underlie the San Fernando Valley, a whisper of the waters the river once spread so wide.

Compared to the wayward Los Angeles River, the aqueduct was a Stepford river. It was clean, constant, modern, and it would very soon make the "limpid little stream" virtually obsolete.

way up the San Gabriel River to the virtually fictitious town of Chicago Park, whose population never numbered more than its caretaker. It is now part of Arcadia.

To this day, some believe that in July 1905, the city fabricated a public "water famine" for its own purposes. A report, made public that hot and dry month, warned that Los Angeles was using four million gallons more each day than the Los Angeles River could supply. Real or contrived, the water panic was official.

THE MOST IMPORTANT PUBLIC OFFICIAL IN LOS ANGELES was not the mayor. He had the title, but the *zanjero* had the power—and a salary fifty percent higher than the mayor's.

The *zanjero* was the water commissioner in charge of the city's ditches, but in practice he was the water god, doling it out here, denying it there, policing every gallon.

The first *zanjero* was hired in 1854; the job was abolished precisely fifty years later, when the last of the *zanjas* closed down. Growers went to

Some floods—
Noah's, and Gilgamesh's—

Taking refuge from the flood

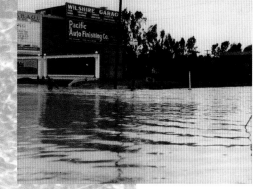

Catalina Avenue at
Wilshire Boulevard

are worked deep into myth, beyond the reach of memory.

The floods of the Los Angeles River must have cast some spell of forgetfulness, because at each big flood, eight or ten years apart, townsfolk were mystified and astonished: A flood? In that dinky little river? My God, how could that happen?

The earth remembered, and the river, too, because they had not changed. But the city had. For every new trainload of sun-seeking immigrants, each flood was the first. A crusty old local named J.J. Warner, who was something of a Cassandra about the river's risks, boomed his warning in the newspaper: "There are many now living in Los Angeles who do not know the magnitude of the volume of water which flows through the city when the river is flooded."

That was in 1882. To this day, fresh generations of Angelenos discover they have a river only when they hear that someone has drowned in it.

SOUTHERN CALIFORNIA HAS HAD MORE wet-and-dry cycles than a Maytag washer-dryer combo. The droughts were leisurely and subtle. The floods, brief and dramatic, made legends, and legends make history.

In the first winter of the Civil War, storms swept a forest's worth of trees downriver. For several years, citizens hunting firewood only had to go forage in the river's debris.

That Christmas Eve, the Boyle family, who lived on the far bank from town, in the neighborhood that would become Boyle Heights, planned to ford the river for a holiday dinner. But the water ran too high, remembered Maria Boyle, "so Father sent word to my aunt by one of our Indians"—*our Indians*—"who swam the raging stream with the message, and then swam back with a goodly portion of the Christmas dinner tied on a large, light board."

But it was the flood of 1886 that gave Los Angeles the epic it

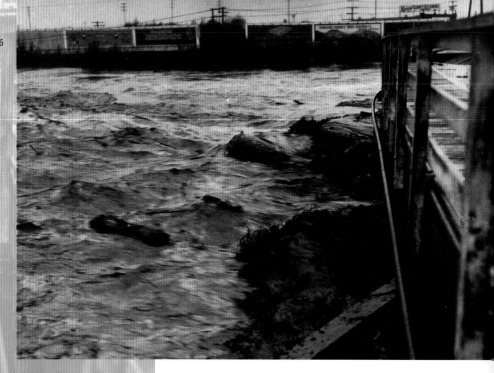

Riverside Drive, 1926

retold for decades. Nine days of rain, and by January 19, 1886, the river was "boiling yellow," and boiling mad. Houses floated off their foundations, their chimneys still smoking cozily as they sailed downriver.

As a horse-drawn streetcar started across the bridge near what is now First Street, the bridge supports behind it began to give way. Passengers ran for the far bank. Then the pilings in front collapsed, and four creatures—two men, two horses—were stuck on a broken stub of bridge. A crowd gathered, the mayor among them, and watched from the soap factory on the banks.

And then Martin Aguirre appeared. No filmmaker's embellishment is necessary here. He actually rode a white horse, named El Capitan. He really wore the badge of a deputy sheriff. He hurled a Bowie knife more accurately than most men shot their guns.

He plunged into the rabid water and rescued both men. And then he rode off, up and down the river, saving, in all, nineteen people that morning. The city was at his feet. He was acclaimed a worthy heir of Spanish cavaliers, and given a gold watch. Two years later he was elected sheriff.

What Martin Aguirre never forgot was the one rescue that failed. He had pulled Theresa Whitney's brothers and sisters safely from a window of their floating house, but as he lifted Theresa and put her on his saddle, El Capitan slipped and went under. Aguirre set the child on a floating fence to right himself and his horse, but when he turned back, Theresa was gone.

As for the stranded streetcar horses, neighbors rowed out to them with food and water every day until they could be brought ashore.

The first great flood of recent memory had to be sheer revenge. In November of 1913, the monumental Owens Aqueduct had opened—a perfect, artificial river. The Los Angeles River was now officially obsolete.

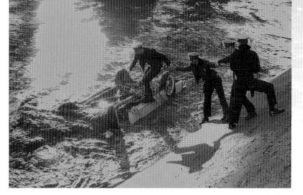

Police rescue truck in the 1950s

Three months later, in February 1914, the river reminded the city that it was still there. Its floodwaters took out a steel railroad bridge above downtown. The quicklime plant tumbled in. The collapsing salt factory in Long Beach sent twenty thousand tons of salt into the saline Pacific. The ranches of Watts were swimming-pool deep. The *Los Angeles Times* delivered food—and newspapers—to Compton by rowboat. Over the roar of the waters, people heard the boom of dynamite, breaking up the debris that backed up the river. The waters had rampaged down from the San Gabriel Mountains so powerfully that ten years later, workmen digging a foundation in South Gate found flakes of placer gold.

The 1914 flood spurred the city fathers to create the flood con-trol district that, to this day, commands Los Angeles' waterways, wet and dry. But the most pathetic story of the 1914 flood had to be the mass pigeon drowning.

Since 1892, tourists had, yes, flocked to the world's biggest pigeon farm, set on the riverbank at Elysian Park. The floods of 1914 yanked in the long poultry sheds, drowning hundreds of thousands of birds. The ones that managed to straggle ashore were roped and hooked by men looking for a free dinner. For days, the survivors circled mournfully over their vanished dovecotes.

Twenty years later came the New Year's Eve gullywasher. Rain—a dozen inches above Pasadena in forty-eight hours, twelve inches in twelve hours above Bel-Air—spilled over the dams and cracked the levees. The mountain creeks and arroyos awakened from their dry beds. The midnight waters began stampeding through Montrose, and a dozen people were killed by an avalanche of boulders and mud thundering into the American Legion hall.

Tujunga and La Crescenta were cut off. After the water left the hill towns, spinning away houses and cars by the hundreds and shoving truck-sized boulders ahead of it, the flood surfed through Glendale. It took out cages at the Griffith Park Zoo, the forerunner of the present city zoo, and freed some of the bears. Mary, a young Sun bear, was coaxed back into a cage by a keeper who laid down a trail of candy for a mile in front of her.

The overwrought river nearly wiped out the Lincoln Park alligator farm. Before World War I, Lincoln Park was an early Disneyland, and on

fine weekends—aren't they all?—townsfolk strolled the wooden foot-bridges over the river to see the alligator wrestling, the ostrich farm, and the Selig Zoo, where a film producer charged admission to gape at the wild animals he rented out to the movies. New York has legends of alligators in the sewers; on this New Year's Day 1934, Los Angeles truly had alligators in the river. Alligators swam free again in a flood four years later, and by 1953, neighbors had had it with free-range reptiles. The alligator farm moved to Buena Park, across the street from Knott's Berry Farm.

In that same flood, when the water hit the plain, it spread wide and fast. In Hollywood, a man who waded across Hollywood Boulevard in shin-deep water found to his delight that the torrents had washed parti-cles of gold off the hills and into the cuffs of his pants. Woody Guthrie lived in Los Angeles then, earning a dollar a day singing on the radio. He wrote a song about the flood, which goes in part:

Kind friend, do you remember
On that fatal New Year's night?
The lights of old Los Angeles
Was a burning, oh, so bright;
A cloudburst hit the mountains,
It swept away our homes,
And a hundred souls was taken
In that fatal New Year's flood.

"Los Angeles New Year's Flood" by Woody Guthrie

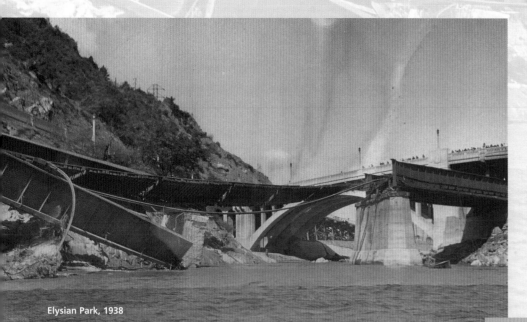

Elysian Park, 1938

What seemed especially sinister is that the river came bellowing out of control at night, and on a holiday, as people were about to head to Pasadena for the Rose Parade, whose theme that year was "Tales of the Seven Seas."

But it took the epochal flood of March 1938 to convict the river as a mass murderer, and sentence it to a life imprisoned in concrete. Nearly a hundred people died, and scores more went forever missing. The

The Renegade River

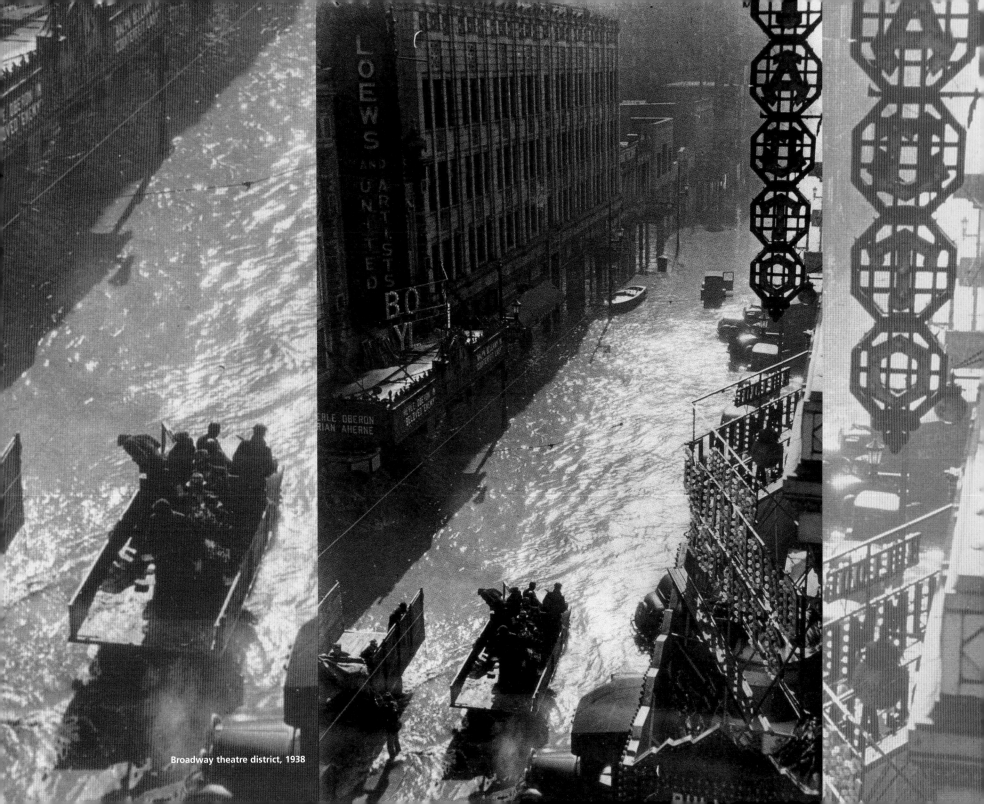

Broadway theatre district, 1938

Men play after the flood, circa 1914.

Milkman makes deliveries in 1938 flood.

floodwater shoved boxcars into the river, and the bridges right after them. In Long Beach, a bridge went down, taking with it ten people who had been standing on it gaping at the spectacle of water. Five more went to their deaths when the Lankershim Boulevard Bridge at Universal City crumpled and tumbled in. When a Hollywood baker heard the news—the mistaken news, as it turned out—that the Big Tujunga Dam had burst, he went briefly mad, chasing after his wife and other people with a butcher knife and a hammer. Yet in Lennox, two boys made the best of things, and went swimming down 111th Street, practicing their crawl stroke.

Los Angeles' sheriff was Eugene Biscailuz, one showman of a lawman who rode in parades on a silver-saddled palomino. In 1938, Biscailuz's air squadron flew over the foothills and dropped beribboned bundles to the marooned cabins. Inside each was a color code—one color for food, another for medicine, a third for fuel. The planes circled again to see which ribbon color had been laid out by the stranded hill-dwellers, and came back a third time to drop the supplies by parachute. Pack horses carried food up into Laurel Canyon.

Nonetheless, in the spirit of willful denial that has become imprinted on Southern California's DNA, the mayor of Los Angeles, the utterly corrupt Frank L. Shaw—who within months would become the first American mayor ever recalled—went on an emergency national radio hookup to chirp, "The sun is shining over Southern California today and . . . Los Angeles is still smiling."

BEFORE THERE HAD BEEN A RIVER, there was a sea—*Mare Angeli*, let us call it, an inland ocean of nine million years past. Eons after the sea departed, people were perplexed to find, high on the slopes of places like Topanga Canyon, the fossils of whales. These are still so plentiful that when yet another one arrives at a Los Angeles museum, it is catalogued in the curators' lingo, if not in their records, as AFW, another freaking whale.

The floodwaters of 1938 turned the plains of Los Angeles into an inland sea once again. Venice was as wet as its aging canals. Long Beach was a virtual island, surrounded by the river and the ocean. For two days, the modern city, home to Hollywood and airplane factories, was cut off from the world.

The flood was to the novel *City of Angels* what fire was to *The*

Long Beach Harbor

Day of the Locust—the climactic event. Rupert Hughes' book begins with a car screeching to a halt on a bridge over the river, and people tumbling out to stand at the railing and laugh at the dry bed, "laughing in their ignorance, at the empty lair of an absent dragon." At the end, the river-dragon resumes its death-dealing ways and inundates Hollywood and the rest of the city. Curtain—soggy curtain.

The movie studios of Warner Bros. and Republic, along the river in Burbank and Studio City, where CBS and Disney now make entertainment, were stranded. To pass the time, Warner's employees put on a show on a dry sound stage. And in a moment only Los Angeles could manufacture, a prop whale, crafted of wood and tin for the shipboard murder mystery *When Were You Born*, was yanked loose by the floodwaters from its moorings at Warner Bros. For a brief and glorious moment, it was free, swimming majestically downriver, a *trompe l'oeil* Moby Dick bound for the freedom of a real sea, not a cinematic one.

To the nation's movie fans, the flood's greatest devastation was that it marooned movie stars in Malibu and at their San Fernando Valley ranches. Thus the Academy Awards had to be postponed for a week.

HOW VERY LIKE LOS ANGELES: a videotaped tragedy became a news story that became a documentary to prevent another such tragedy.

Scores of people had drowned in the winter river before February of 1992—mostly children, mostly boys. "The water held a strange fascination for him," recounted the mother of a toddler who drowned in the river near his house in 1943. "He always wanted us to take him across the street to the river channel." Nine years later, a three-year-old Bell Gardens boy whose small cousin nearly drowned offered the most forlorn explanation for what they were doing in the water: "We were looking for whales."

Boys on inner tubes, boys on bikes, boys in their bare feet, boys with surfboards, boys who climbed fences and slipped through gates marked with no-trespassing signs—decade to decade, the dead boys' stories repeated themselves. August 1936, a fifteen-year-old playing Huck Finn on a makeshift raft; March 1969, an eight-year-old boy amusing himself at the water's edge with his brother; October 2000, a pair of third-grade friends playing on a dam near the river in Long Beach.

No signs have ever been big enough, no fence ever high or barbed enough to foil them all. The father of one of the dead Long Beach boys told the newspapers that he had harped on it and harped on it to his son, "stay out of the river, stay out of the river," until at last the boy said, "Okay, dad, you don't have to say it no more."

TWO NOTORIOUS DROWNINGS, a dozen years apart, may have saved more lives than all the signs and fences. One was documented hauntingly by news cameras, the other was evoked indelibly on film by the drowned man's fiancee.

Earl Higgins came to Los Angeles from Denver in the summer of 1979 to try his hand at screenwriting. His fiancee, Nancy Rigg, arrived some months later, in winter sunshine. The couple were walking their dog

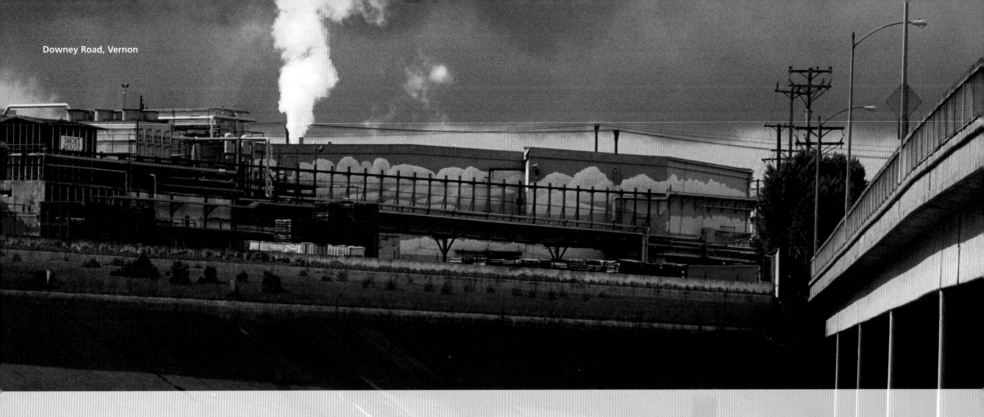

on the Sunnynook footbridge over the river in Atwater. Below them were two boys riding bikes on the sloping riverbanks. Jimmy Ventrillo's bike got caught in the current, and when he made a grab for it, he, too, was pulled in. Earl Higgins raced off the bridge and into the water to save him, and was borne away. A freak eddy flung Jimmy Ventrillo back onto the banks, alive. Earl Higgins' body was found nine months later.

A dozen winters later in February of 1992, a teenager named Adam Bischoff, who had been a toddler when Earl Higgins drowned, was riding his bike on the river's flanks near Woodland Hills. He, too, went into the speeding water. As he passed under bridge after bridge, people dropped floats and ropes to him that he could not catch. A cop looped a garden hose around his waist and waded out with an aluminum pole for the teenager to grab. In the end, Adam Bischoff drowned.

Television cameras sent images of his pale, terrified face into living rooms, Nancy Rigg's among them. To the cause of her fiancee's death she added that of a boy she never knew. Two benefits would come from these two losses: the creation of a Los Angeles County swift-water rescue team, and a twenty-minute warning video, including Adam Bischoff's very public drowning. The video Rigg produced was called "No Way Out," and it is shown in classrooms every year as part of the curriculum.

The river isn't to blame. As a real river, it had its perils. But as a fake one, designed to speed water as efficiently as new copper plumbing, it can be deadly. It is the difference between the flu virus and Ebola. The water czars figure that the river on average takes six lives a year. Yet in a place with 470 miles of open water channels, a place with nearly ten million people whose acquaintance with running water extends largely to faucets and fountains, six is a low number.

Adults' encounters with the re-engineered river seem either more comical or more sinister. In 1998, a car thief with police on his tail drove into the river. He crawled out of the sinking car and scampered up the

bank. Cops yelled at him to reach back and grab his girlfriend, but he left her to drown. He went to prison for involuntary manslaughter.

In the fledgling age of on-the-scene television news, three South Gate men launched a kayak into the river in November of 1966. It capsized about three hundred yards downstream. Two waded ashore. The third, who said he was a fine swimmer and didn't need a lifejacket, stayed with the boat. The last his pals saw of him, he was bobbing downstream with the kayak.

Afterward, one of two survivors admitted to a reporter from that old-fashioned medium of newspapers that it was all a publicity stunt. "We called ABC television Monday afternoon and told them when and where we were going into the water. Being a painting contractor, I thought the publicity would help. Their crew didn't make it but we decided to go ahead anyway."

And they must have had stories to tell back at the fire station on Hallowe'en night in 1987, when firefighters were summoned to swing a ladder out over the river and sent down rescue harnesses to pluck two stranded men from the roof of their engulfed car. One of them was costumed head to toe in a pink ballerina ensemble.

The cruel truth of it was, once Los Angeles possessed a perfectly behaved trophy river in its new aqueduct, its original river, the real river, had become an ex-wife. She wasn't much to look at, her useful days were pretty much over, but she was still capable of making a great deal of trouble when she chose to. And from time to time, she certainly chose to.

A FLOOD WAS A DIFFERENT CREATURE in 1870 from what it would become by 1920. When the land was given over to grazing and growing, a flood was at most a mere inconvenience. When water began to chew away at California gold—land and houses—it was no longer benign. It became, in the vocabulary of the city, *the enemy*, and the dilemma of what to do about it was cast thereafter in the language of war.

If you set out to design a flood-making machine,

Bridge collapse, 1938

you would wind up with
Los Angeles.

No river is ever just a neat seam on a map. Each gathers its waters from far and wide, and the watershed of the Los Angeles River embraces 835 square miles, bigger than the island of Maui. Add to that the watershed of its sister rivers, such as the San Gabriel, and you have an area the size of one and half Rhode Islands, spiked with peaks nine and even ten thousand feet high.

From the eastern edge of Malibu, across the mountains to the peaks above Pasadena—creeks and springs and mountain glades, snowpack melting within sight of sun decks—almost every drop of water heads like a homing pigeon toward the Los Angeles River.

This is why a river with a no-class reputation has had world-class floods. As an exaggerated but illustrative example of the drought-and-deluge geography, imagine the Cascades up against the Australian outback. Heavyweight storms hit the mountains above the Los Angeles basin with the force of a big-rig smacking into a retaining wall. Marc Reisner, whose book *Cadillac Desert* is the alpha and omega of water in the west, pointed out that the twenty-six inches of rain that fell in one record-setting day in Santa Anita Canyon near Pasadena was more than twice the rain that normally falls across the Los Angeles basin in an entire year.

Compare the Los Angeles River to the Mississippi—no, seriously;

Construction of channel walls,
Laurel Canyon, 1949

the hydrologists do. From source to mouth, each river drops about eight hundred feet. The difference is that the Mississippi takes almost two thousand miles to descend that distance. The Los Angeles River does it in fifty-one miles. It's like comparing a wheelchair ramp to a water park slide.

In a village of a thousand Indians and *gente de razón*, an occasional flood didn't matter. In a pueblo of farms and ranches, it was even welcome, the way the Nile's floods were a blessing in the desiccated river valley of Egypt. Writing in a historical society publication, J.M. Guinn declared that floods that elsewhere "are wholly evil in their effects," in this region, are "although causing temporary damage, [they] are greatly beneficial to the country. They fill up the springs and mountain lakes and supply water for irrigation. A flood year is always followed by a fruitful year."

But in the modern metropolis that progress-minded land barons were hellbent for Los Angeles to become, nature simply wouldn't do. As a nineteenth-century Angeleno declared, "Water is a good servant but a poor master," and the city determined to master it.

LEAVE THE WHIPSAW FORTUNES OF gold mining to the placer chasers up north; Los Angeles has always banked on real estate, land, terra firma, for its fortunes. Its land has been doled out in shrinking units and growing prices: by the league, the acre, the hectare, the square foot—someday, perhaps, by the carat.

And the more valuable land became, the less worthwhile the river was. It simply couldn't be allowed to take up so much room, and threaten so much more, wandering as it pleased hither and yon.

Riverfront property was never the priciest in town, but still, it was

Vernon

Washington Boulevard Viaduct

land, and it was bought and sold—one way or another. In 1909 the mayor, Arthur C. Harper, was hounded out of office for running an open city—legal gambling and whoring—and for letting his cronies try to steal the rights to the river bottom.

At the dawn of the twenty-first century, several dozen people still owned property in the riverbed and its tributaries, stubs of bigger parcels, or land bought as the river was getting its concrete facelift in 1938. Much of the Big Tujunga Wash belonged to a golf course outfit. One man trying to unload four acres near Elysian Park finally got a nibble—from a Japanese man who heard the word "river" and imagined building a restaurant where diners could fish for their own dinners right out the windows.

Alfred Moore, a real estate broker of the booming 1880s, bragged in the pages of the *Los Angeles Times* that he had sold six river-front lots "to a lady who has since built a very fine residence within a few feet of the river." The neighbors "gathered round her and spoke of the overflow, and tried to scare her off buying." She retorted, "'Bosh, when the flood comes I can swim anyhow.'" And anyway, concluded the real estate man, "if there is any danger from an overflow . . . the authorities should see to it in time to prevent any disaster."

Such was the faith that in Los Angeles, property was paramount, and government's job was to protect it. In the next century the real estate man would be proven right; the authorities would indeed see to it.

IT IS A WONDERFUL IRONY THAT the Army Corps of Engineers, which has jurisdiction over the nation's navigable water-ways, took control of the Los Angeles River.

By any recollection, no boat bigger than a canoe has ever managed a trip upriver or down. One can gauge the depth of Los Angeles' wartime fears by citizens' panic at reports of Japanese submarines sneaking into

Queen Mary, Long Beach Harbor

the river from Long Beach—a feat no sailor has ever been able to perform. The fact that the Queen Mary, one of the grandest liners of the great age of ocean travel, is moored in cement at the mouth of one of the world's least navigable rivers is just another little tidbit for the wits.

THE ARMY CORPS' ENGINEERING of the river would be the most monumental, but it was not the first.

People had been fiddling with the river almost since there were people to fiddle. Early settlers put in a *toma*, an intake, on the river near the original pueblo, to direct water into the *zanja madre*. During the Civil War, an engineer named George Hansen suggested that a willow reed called mulefat be bundled up and buried horizontally to make the riverbanks more stable. At its first meeting after former mayor Marchessault's suicide, the city council debated straightening the river, and levying a quarter-percent tax to pay for it.

City-approved levees made of earth rose up here and there along the banks of the nineteenth-century river. Gentlemen ranchers were always pontificating about the river, among them Henry Gage, who would become the first California governor of the twentieth century. He lived in his wife's family home, the Lugo adobe in Bell Gardens, where the Los Angeles River and Rio Hondo join their waters. Gage kept after his neighbors to let their sheep graze in the dry riverbed in summer to keep the bed cleared for winter floods—something the flood control patrols now do regularly with machines.

After the floods of 1914, Los Angeles decided it was high time to start a county flood control district. Congress sent some money west, and over twenty years, local voters pressed the "yes" lever for millions of dollars in flood control bonds about as often as they voted "no." Engineers and politicians studied and proposed; let's put the river here, let's move it over there, stick in a dam up yonder. But piecemeal local remedies—like the 1920 Devil's Gate Dam in Pasadena—were, to the

Burbank

engineers' way of thinking, like making a quilt by starting with patches set a foot apart.

Comic book superheroes were born in the 1930s, and in the 1930s Los Angeles' renegade waters looked like a job for a super-agency. The Army Corps of Engineers had opened up headquarters in Los Angeles on New Year's Eve, 1898, setting to work on the harbors. It would later rank the Los Angeles River as having the greatest potential for flood damage of any river west of the Mississippi. To both Congress and the Corps, flood control and navigation were so entwined that a feckless river in which no ship could travel became a natural extension of the Corps' kingdom. The river was federalized.

The timing was perfect. The Long Beach earthquake of 1933 was followed by the mountain floods of 1934. By the mid-1930s, Los Angeles had had just about enough of nature in the raw.

Los Angeles needed a river that wouldn't overrun all that valuable real estate, and millions of men needed work. In the space of a single year—from the summer of 1935 to the summer of 1936—the Army Corps of Engineers in Los Angeles went from fifteen employees to seventeen thousand.

The numbers, like all numbers during the monumentalism of the Depression, were astounding: between 1936 and 1958, the Army Corps' flood control projects moved twenty million cubic yards of earth, set almost one hundred fifty million pounds of reinforcing steel, and poured two million cubic yards of concrete using three and a half million barrels of cement (the Corps, like the Colonel Sanders of cement, formulated its own recipe for concrete mix).

A project on that scale was like a dress rehearsal for war, and chroniclers were lavish with the combat metaphors: "War on two fronts," wrote the *Los Angeles Times*, "battling on two fronts—mountain and valley—to free cities and ranches from this peril." The Corps, the paper trumpeted, was acting with "the typical, clearly defined exactness and certainty with which Uncle Sam's Army engineers prepare defenses against any enemy."

In a later age, a cooler pen, that of writer John McPhee, crafted the phrase, "the control of nature," which could fairly be the motto of the American West.

Nature insisted on resisting. The 1938 flood unearthed part of the river's newly poured concrete bed and washed it out to sea. To this day, several miles of the river—from the Bette Davis picnic grounds in Griffith Park to Dodger Stadium—have a "natural bottom," meaning it is not completely concrete. The water table is too high, the river too persistently wet for concreting.

Only now and then did the admiring press nip at official heels. A 1934 county flood control internal memo fretted that a water official's expense report was too low in some things—"a hotel room at the Plaza, New York City, at five dollars a day, and I don't think they'd let you use the lobby for that"—and too high in others—fifteen dollars a day for meals! "Something is likely to happen about this," the memo's author warned. "I understand the *Hollywood Citizen-News* is to poke fun at the expense account in today's issue."

But that was quibbling. Officially, Los Angeles was awed, overwhelmed, thrilled and most of all relieved at the project. When ground was broken in 1940 for the new Sepulveda Dam, Hollywood enlisted in the water war and sent out three starlets—among them Ronald Reagan's first wife, actress Jane Wyman—to join the politicians riding the bulldozers.

Land that flooded even irregularly would not do so any longer. Like the reclaimed acres behind the dikes of Holland, the plains of Los Angeles, now walled off from the river that had both nourished them and overrun them, were considered safe, and were promptly divided and subdivided, sold and resold.

In the fall of 1949, the Corps staged a dress rehearsal, a dry run for flood, as the city now occasionally does for earthquakes. It simulated a twenty-inch rainfall in the mountains and met the deluge with one hundred sixty pieces of flood-fighting equipment, and everything went . . . swimmingly.

By June 1953, H.E. Hedger, the chief engineer for the county flood control district, could declare, "Thus, where but a few short generations ago, the land was considered as but fit for pasture in favorable season, today great cities stand proudly and secure upon the Plain."

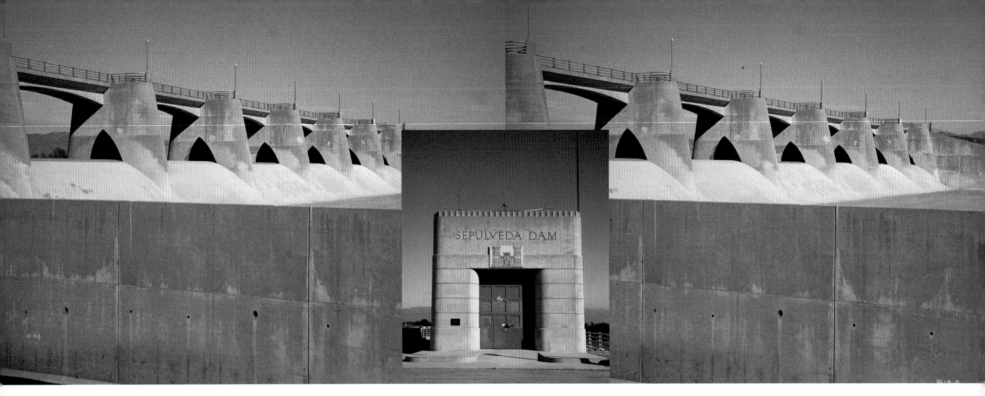

SEPULVEDA DAM

OFFICIALLY, FEW VOICES WERE raised against the concrete frosting of Los Angeles' waterways.

One was a well-respected voice, but it would be Cassandra's—prescient, and destined to go unheeded. The landscape architect firm of Frederick Law Olmsted, Jr., the son of the man who designed New York's Central Park, was invited here with another firm called Bartholomew & Associates, to make assessments and recommendations about park-starved Los Angeles County.

The river's potential in particular caught the designers' attention. Why not, they proposed in their 1930 report, buy up some of the land flanking the river—about a third of the river's present length in all, land that was too iffy in flood season to use for homes or businesses—and turn it into a chain of interlinking "pleasureways?"

Doing so would solve two dilemmas: create vitally needed park space, and acknowledge "hazard zoning" by keeping risky riverbank land from being overdeveloped. Even as the report was written, its authors pointed out, a four-mile stretch from Griffith Park toward the Tujunga Wash, "a good location for a parkway," was already "being constricted to an ugly deep channel and the channel is being crowded on both sides." (Vacant land does indeed frame some of the river now, but it is usually the sterile empire of power lines, utility rights-of-way and railroads.)

In time, the city would have some pangs about the esthetics of its river. When it occurred to the city fathers in 1935 that the typical visitor's first sight of Los Angeles was the river, as seen by train, they made a pitch for federal money—not to improve the river, but to disguise it by planting three miles of palms and pepper trees along the banks between the rail lines and the riverbed. But nothing came of it.

In 1938, Los Angeles began planning a party for 1942, a

Highland Park, date unknown

celebration of the four hundredth anniversary of Spanish explorer Juan Cabrillo's arrival in California. The most immediate concern was the "raw cleft" of a river. To remedy that, a planning commissioner suggested creating "a delightful lagoon" by damming the river, making parks on the desolate banks, showing off the fine bridges, and laying scenic roadways on either side of the river "for a considerable distance toward the river's mouth." But instead of an exposition, the city found itself planning for World War II.

WHAT WAS OF INCALCULABLE VALUE to Los Angeles, the Olmsted plan argued, was the beauty and quiet of open space, free from the clutter of commerce and the intrusions of the outside world.

> The beaches are being fenced off and withdrawn from general use with alarming rapidity. There are no large parks or permanent public open spaces along the coast . . . the mountains, which are dominant scenic assets, are slowly losing value because of the intensive urban growth . . .

The plan was visionary, ambitious and, at the cusp of the Depression, stupefyingly expensive. Businessmen, the demi-gods of Los Angeles, didn't like it one bit, and saw to it that the plan was filed away and forgotten. Imagine taking all that land off the real estate market. People buy houses and groceries and automobiles—parks don't.

The Corps' billion-dollar flood-control waterworks would be even more expensive, but that money came out of federal pockets. Its benefits were immediately obvious in a way that the advantages of the Olmsted plan were not, and would not be for years, by which time it was too late to make them happen.

Army Corps of Engineers working model,
L.A. River flood control system,
Vicksburg, Mississippi

THE STORY OF THE CORPS' LABORS in Southern California is recounted in a handsome and hefty red-bound book published by the Corps and written by its history consultant. In the Corps' offices in Vicksburg, on the Mississippi River, the flood control mechanisms of the Los Angeles and its sister rivers are laid out like an enormous science project in an acre-sized working scale model.

And why shouldn't the Corps boast? Constructed in an age that built as monumentally as the pyramids, the Los Angeles flood control system was an engineering marvel of its time. "The unruly Los Angeles River," ooohed the *Los Angeles Times*, "has been strapped on a laboratory table."

All that steel and cement and sweat brought forth four hundred seventy miles of open channels, twenty-four hundred miles of covered storm drains and ninety-eight thousand curbside openings into those storm drains, 123 debris basins, three reservoirs, several large dams and hundreds of crib dams and catchment inlets and debris basins, and a score or more pumping stations.

Like the freeways, the flood-controlled river and its tributaries put a premium on speed, volume and efficiency. At optimum operation, the system was designed to work in sync, like a huge, ingenious pinball machine. There are holes to catch boulders and other junk, flippers to send the water this way and that, tunnels where the water can drop down and disappear and pop up again elsewhere, shunts, chutes and slides.

Building the river was a billion-dollar, thirty-year project. Sixty years later, hundreds of workers still tend it with eternal vigilance. Flood control is no longer the work of neighborhood volunteer sandbaggers but the beat of professional nature police patrolling a concrete kingdom. In rainy weeks, the county's flood control workers are on high alert, hustling to troubleshoot the debris basins and dams, timing the water flows down

the cement channels. In dry months, they make the rounds, cleaning the drains, scalping the riverbeds clean of any vegetation that manages to break through, scraping away stray rocks and rubble. They keep the pinball machine in good repair against the day the sky splits apart and the waters smack the mountains again.

TRY TO RENDER FIXED AND PERMANENT A LANDSCAPE that changes with every spatter of rain and shiver of the earth, and of course there are repercussions.

The beaches, for one. Unlike other beaches that are replenished by the ocean, Los Angeles' beaches always counted on three rivers—the Los Angeles, the San Gabriel and the Santa Ana—for fresh sand. But once the rivers were paved, that source dried up, and the beaches began receding. "Resolving one vital problem," the Corps acknowledged, "developed a new one."

And there was this greater quandary:

An imprisoned river makes more land "safe" for development. More development meant more paving. And every new bucket of asphalt and sack of concrete means one more patch of soil is being covered up and can't absorb rainfall.

So, instead of nestling down into the earth and renewing the underground reservoirs of Los Angeles' watersheds, raindrops bounce off the paved-over places like marbles. Keep paving and building, and ultimately, the rain has nowhere to go but into that artificial river. And more water in the river means that the flood control people insist that the channels must be made, in the words of the Olympic motto, *citius, altius, fortius*—even faster, higher, stronger.

Naively, perhaps, the Corps' planners, like other people, had expected that a fair portion of suburban Los Angeles—thirty or forty percent—would stay farmland and park land, giving the rain somewhere to go besides their brand-new river. But the real estate gods dictated otherwise. Even before the Corps set to work, "river creep" had already begun. Subdivisions started to close in on the river's historical turf down on the flats and along washes and creeks up in the hills.

And after the Corps was done, urban development, which in Los Angeles was already about as orderly as a malignant tumor, was unchained. Earthquake risk had never even slowed growth. If land was officially safe from floods, why not build?

And the river, which had never been uniformly beautiful but had at least been real, ceased to be either. Riverside Drive twined for miles along the cement channel, but those who drove it had no notion that it was not named for a Southern California city, but for a real watercourse, right there below their radials.

The "R" word, river, did not often cross official lips. The newspapers began capitalizing it: "Los Angeles Flood Control Channel." The river's almost instant invisibility was a testament to the single-minded efficiency of a flood control system which mimicked in the discipline of concrete what had once flowed capriciously through soil and sand. And in time, the millions who lived here also stopped calling it a river, and even stopped thinking of it as a river. It was a flood control channel, eerily vast, watchful, waiting for a disaster to earn its keep, as useful and as unlovely as a freeway, and as little deserving of a second look.

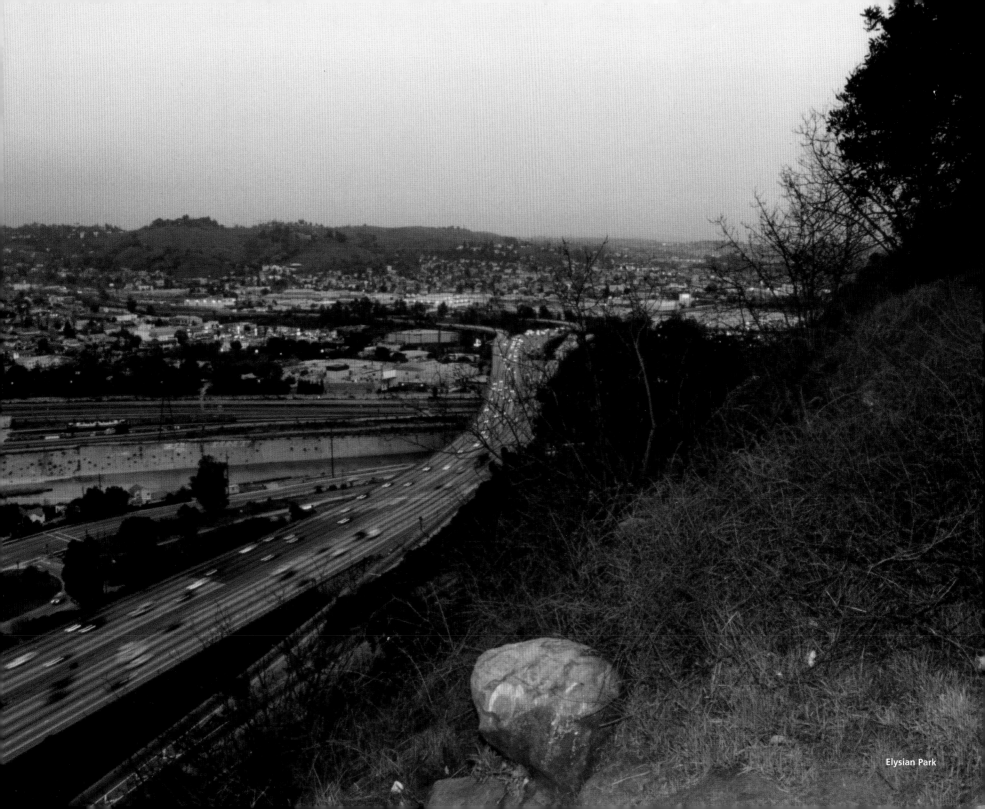

Elysian Park

"*The river is nothing,*

Freeway exchange, Compton

Bridge 53-582, Bell

but the bridges are sensational."

The man who pronounced this paradox, a Los Angeles architectural historian named Robert Winter, would pass a lie detector test with room to spare. The river may be dry, the freeways dull, but the bridges are indeed spectacular.

In the span of a few miles, Los Angeles possesses one dozen of the handsomest bridges in the nation, engineered rainbows of beauty and utility, all built between 1910 and the Great Depression, every one of them on the nation's official register of historic places.

No other city anywhere has such superb bridges over such an inconsequential river. It is as if someone shook the box of pieces in a board game called "Bridges of the World," and dropped along the Los Angeles River the spans of Florence and Budapest and Barcelona and Avignon.

And the man who built most of them was a high school graduate who studied engineering by correspondence course.

In a place where the word "bridge" is heard more often from a dentist than an engineer, how did this come to pass?

A CIVIC MOVEMENT THAT SPANNED the nineteenth and twentieth century the way these bridges span the river was called the City Beautiful movement. It sounds precious now, but its premise was that fine buildings influence people to become fine citizens.

In a growing Los Angeles, as in other places, the railroads were a city's jugular and carotid, and what the railroads needed, they got. All that was asked of railroad bridges is that they worked. The railroad trestles angling across the river had as much style as an upended Erector Set.

Eventually, trains and cars were crossing paths too often. At the end of World War I, on Alameda Street, streetcars and automobiles and pedestrians all had to come to stop for a total of almost two hours out of twelve each day to make way for the trains. The civilians needed their own bridges, and for that Los Angeles turned to Merrill Butler.

Butler spent forty years working in Los Angeles City Hall, and he studied engineering by correspondence course. Either that was one bang-up correspondence school, or Butler was a natural. He designed nine of

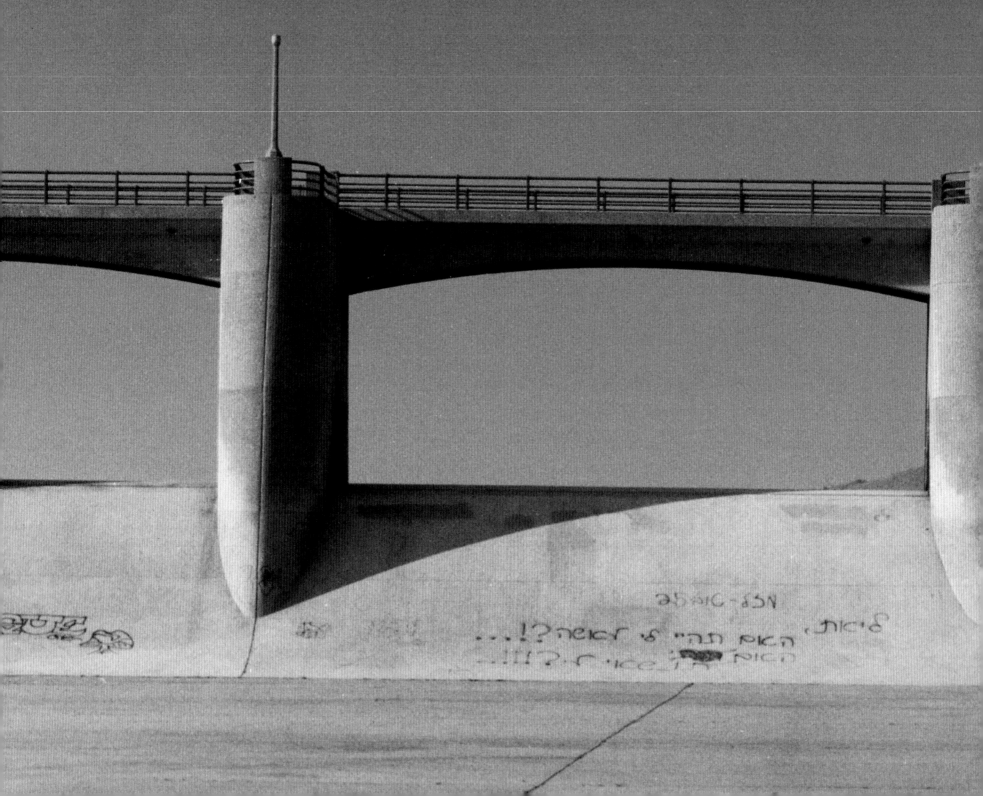

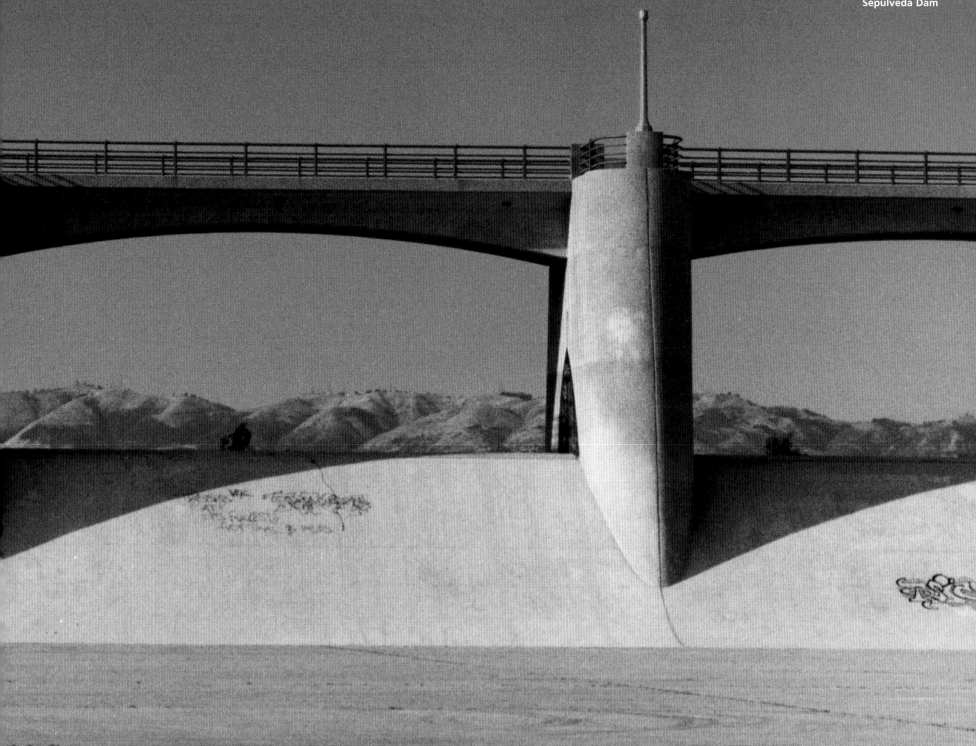

the splendid river bridges, as well as the stylish tunnels of the Pasadena Freeway.

They were built mostly of reinforced concrete—the same basic material that would soon enclose the river. And they were monumental. Truly mon-u-mental. The Sixth Street bridge is two-thirds of a mile long. When James Rojas, whose grandfather worked on paving the river, crossed the Sixth Street bridge on the bus from East Los Angeles, "it felt like crossing the Mississippi because it was so long."

As befits a city that builds Cape Cod houses next door to Greek Revival manses and across the street from Mission bungalows, each bridge has a distinct character. Each is uniquely defined, from the Spanish colonial ornamentation on the Macy Street Bridge—now the Cesar Chavez Avenue Bridge—to the bright terra-cotta reliefs of bridge builders on the pylons of

the Washington Boulevard Bridge, and the *memento mori* austerity of the Glendale-Hyperion Bridge, dedicated to the dead of World War I. Some of the original touches lost over the years were restored in a late twentieth-century seismic retrofit. For that, credit Clark Robins, the city engineer who was not satisfied with merely making the bridges safe but wished to make them look as they once did.

The city has been flirting with the notion of playing spotlights on the bridges at night; perhaps they should choose a different color palette for each bridge. With the river in a dreary state, a bit of high-wattage, Technicolor bragging about its bridges wouldn't be out of line.

THE REASON FOR THESE BEAUTIFUL BRIDGES, as set forth by an engineer in 1923, is to "excite comment from visitors who enter and leave the city by

First Street Viaduct

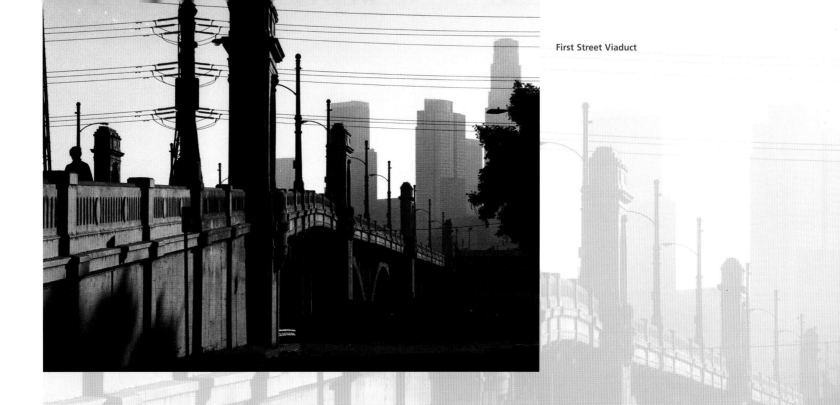

railways," and "raise the status of Los Angeles as an enterprising, properly developed city."

That presumes the bridges will be seen. In the hurly-burly of traffic, it is hard to get a good look at them. A seat on the train is still the best vantage point for bridge-viewing, but how many people take the train to downtown Los Angeles?

The bridges were built to be strolled across, too, but hardly anyone does. The Buena Vista Bridge, now the North Broadway Bridge, was designed with twelve viewing balconies. The Fourth Street Bridge has sets of curved steps at each end, but its most frequent pedestrians are the pathetically deranged or the vicious who smear it with human filth and the vandals who defile it with graffiti.

The fault lies not in our spans but in ourselves. Angelenos are more likely to cross a bridge in a Lexus than in loafers, and if one lingers on a bridge in these parts, someone else is likely to call 911 to summon the men with nets and bullhorns.

THE FIRST BRIDGE of any consequence over the river—apart from rickety footbridges which, like white linen pants, never lasted more than a season—was built in 1870. For reasons no one can now fathom, it was a covered bridge, more Maine than Main Street Los Angeles. And yet storm after storm, the wooden bridge at Macy Street was the only one left standing, until time and a good strong flood in 1904 took it down.

The local taxidermist tended the bridge. He lived at its west end, and walked its length each evening, lighting the coal-oil lamps that illuminated the creaking interior. He went back every morning to snuff them out.

What is it about a bridge that draws a crowd? People came from as far away as San Diego to see the covered bridge. In 2000, when the

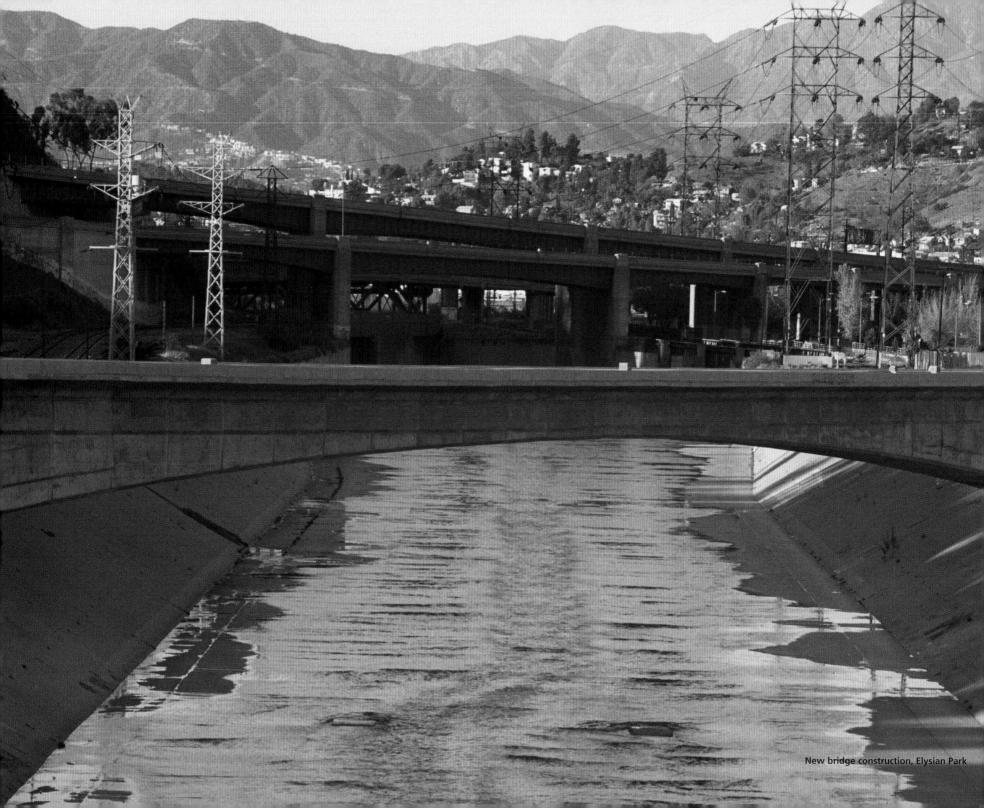

New bridge construction, Elysian Park

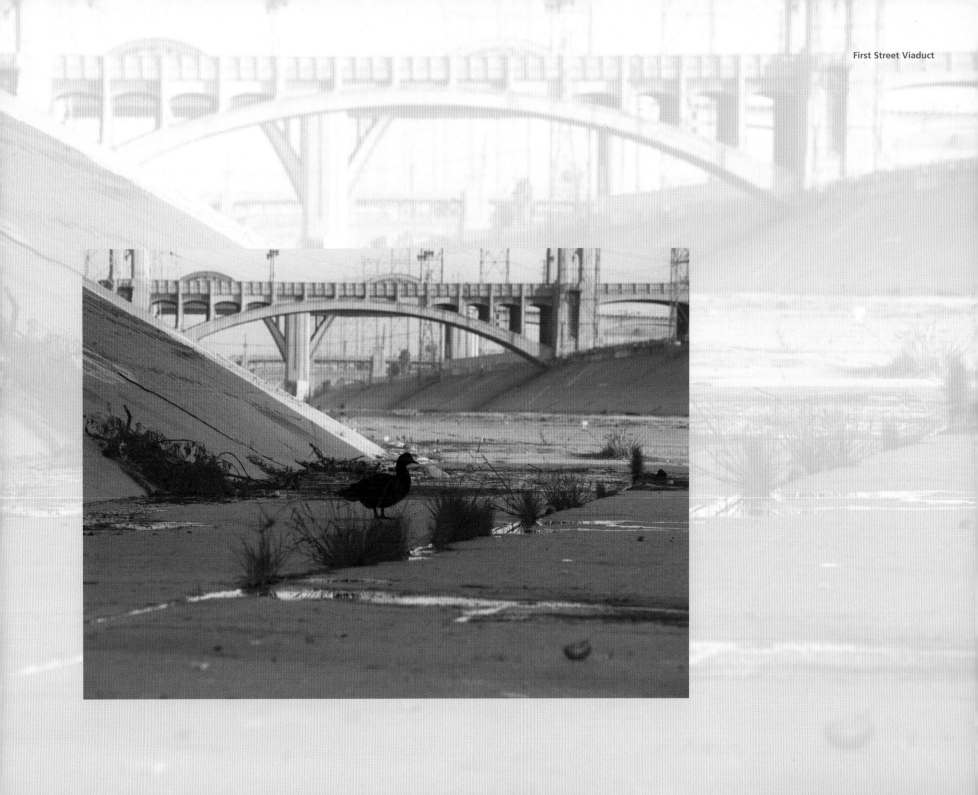

restored Broadway Bridge reopened, reconnecting Chinatown to Lincoln Heights, dragon dancers partied at mid-bridge with a jazz trumpeter named Bobby Rodriguez.

A year after the floods of 1938, Burbank dedicated a new equestrian/pedestrian bridge with a flag-raising ceremony and a fanfare by a boys' band.

In Bell, where the floods had not only washed away the bridge but twenty-five percent of local business, it was no wonder that when the new bridge was dedicated in 1940, fifteen thousand people showed up to party at a rodeo and picnic.

The same year, Gene Autry was supposed to do the honors at

Universal City's new bridge, but he didn't show, and the master of ceremonies made do with a movie donkey named Croppy.

Not to be outdone, Maywood's new Slauson Avenue Bridge opened two years later, with a rodeo and a horse-and-buggy parade, and they enticed the governor of California down from Sacramento to cut the ribbon.

THERE ARE PERHAPS A HUNDRED bridges across the length of the river. Two of them, at least, have not been welcomed with picnics and rodeos. R-1 residents whose homes back onto the river in Studio City went to war in the 1980s with a sex shop across the river on Ventura Boulevard. Hookers, they said, were using the footbridge to do business al fresco. One resident took to illuminating the bridge with a spotlight to scare off the trade.

Up the river in Canoga Park, the city raised up eight feet of chain

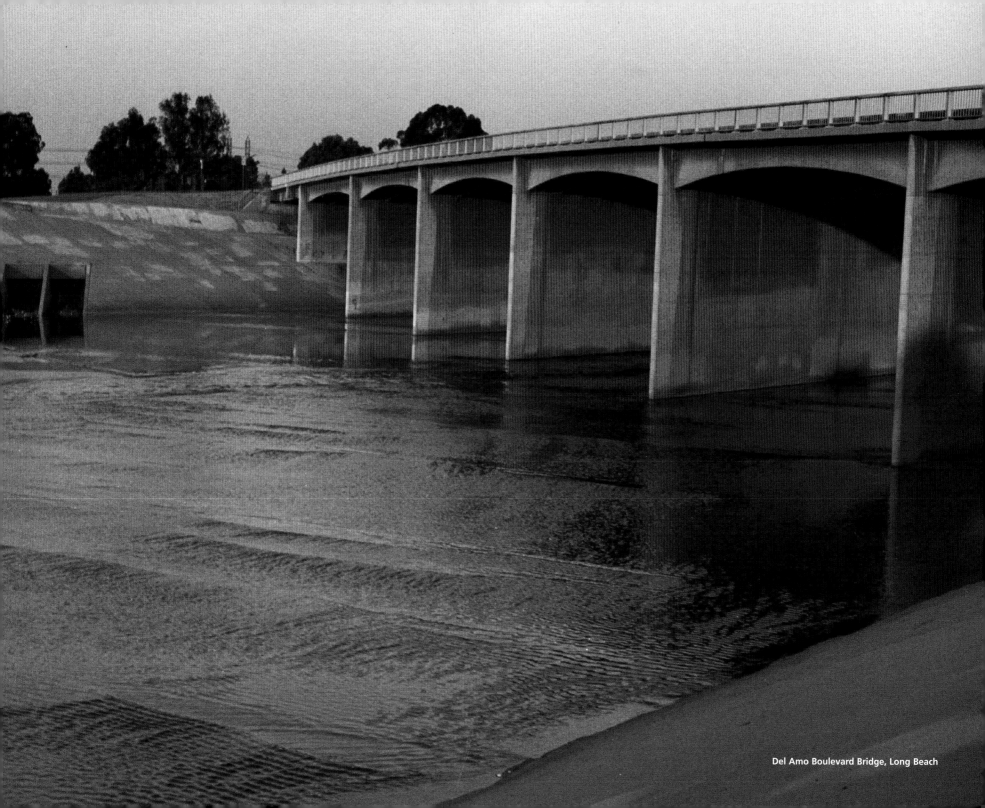

Del Amo Boulevard Bridge, Long Beach

link at the ends of a footbridge to keep out the gangbangers who were in the habit of hanging out there.

Bridge tales are even harder to come by than river tales. But a few persist, like the Singing Bridge of Studio City, and the sad story of the man with the Cadillac.

Throughout the summer of 1956, the bridge at Colfax Avenue had been making odd noises—the audio wizards at the movie studio, more acute in these matters, called them "contralto-like sounds"—and light sleepers and filmmakers were moved to complain. The eerie sound had a mundane source: the thrum of car tires over steel gratings. About eight thousand dollars' worth of cement later, the bridge stopped singing.

On a night in February 1988, an hour after midnight, a man parked his 1970 Cadillac on the Cesar Chavez Avenue Bridge, got out and walked up to the railing. There he stood, staring into the riverbed with its foot-deep veneer of water. Then a passerby called out to him, "You won't be needing that car; can I have it?" The man on the bridge said nothing. He just jumped.

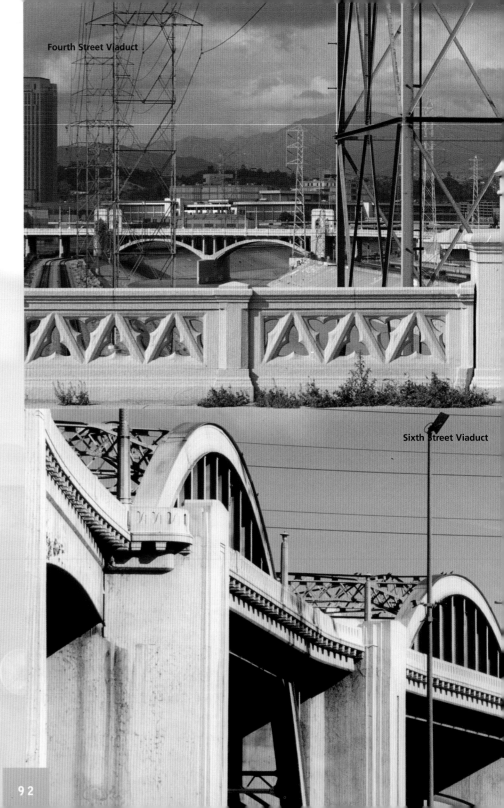

Fourth Street Viaduct

Sixth Street Viaduct

Bridge 53-581, Cudahy

So.

Universal City

If it was no longer to be a river, what was it?

The better question is, what wasn't it? What hasn't the Los Angeles River been?

It's been a rush-hour shortcut, a backlot for movies, a backdrop for artists and a hangout for the homeless, an oil field, a gold field and a landing field.

Once the river was cemented over, and its identity as a river all but blotted out, it became a blank slate, and the relentless reinvention that is second nature in Los Angeles took over.

In the perennial "What shall we do with the river?" contest, the perennial nominee was, "Turn it into a freeway." The latest man to suggest it was a state legislator named Richard Katz. The fact that he was roundly mocked for it may have shown some creeping enlightenment, because when the idea was floated in the 1930s—before Katz was even born—it was taken very seriously.

By March of 1941, the idea had become more elaborate: why not build twenty-four miles of smooth, nonstop riverbed freeway, Burbank to Long Beach, with snug bomb shelters nestled here and there, the way emergency call boxes are now installed along the freeways? The notion got as far as a feasibility study a month before Pearl Harbor before it was abandoned for the duration. (In the war years, before the Harbor or Long Beach freeways were built, freshly minted munitions were sometimes trucked from defense plants down the riverbed to the waiting ships in the harbor.)

But there it was again, popping up in August 1947, when a county official led a "motorized safari" up the riverbed. To the flood-fearful, he declared breezily, "People in Duluth don't disregard their harbor facilities just because they're frozen over a short part of the year."

The freeway idea more or less ran out of gas; no politician picked

Compton

up the torch the next year, when the papers reported without irony that the Western Asphalt Association was urging Los Angeles to turn its riverbeds into freeways.

Hype springs eternal, and in 1985 a county supervisor and lesser mortals gathered at the mouth of the river in Long Beach to hop aboard a hovercraft to "sail" up on a bed of air, still looking for the holy grail of getting around town. The hovercraft operator could not get the engine started.

The closest the river ever came, officially, to serving transportation needs was in the decade or so when the public transit system trained its new bus drivers in the riverbed, where they practiced weaving their behemoth buses among orange traffic cones positioned as an obstacle course.

What the politicians couldn't do, the commuters did. In the great suburban boom of the 1950s, hundreds of drivers took to jumping off the Ventura and the Golden State freeways and steering into the riverbed for the commuter's dream, a shortcut.

"The poor man's freeway," the newspapers called the riverbed in its outlaw incarnation. Cops pulled drivers over and then realized they couldn't ticket them—there was no law against it. The city hurriedly passed one.

In time the teenagers discovered the river. Kids in hot rods came on weekends from as far as Inglewood and Ontario, to race under the bridges and between the pylons, in downtown and in Toluca Lake. In March 1956, more than one hundred fifty of them were marking off a quarter-mile drag strip when police cars came roaring down the San Fernando Road ramp into the river to bust them. As the drivers hauled out their licenses and registration, their nineteen-year-old leader bewailed, "What do you want us to do, race 'em in the streets? We'll go to City Hall tomorrow!"

A few broader-minded politicians did listen to them. A riverbed racecourse near Lynwood was proposed, but nothing ever came of that, and the drag racers too, like the shortcut seekers, got tired of tickets, and left.

Compton Golf Course

THE WAR UPENDED EVERYTHING, and why should the river be exempt? Someone got the bright idea in 1940 of roofing over the river and building defense plants in the riverbed and a freeway on top of that, until the city engineer pointed out that the course of a river—even an emasculated one like Los Angeles'—is an ideal bombing target.

The river did do its bit during the war. Military officials told residents to fill sandbags with river sand to put out incendiary bombs, if the enemy happened to rain any down upon them.

The river stood a likelier chance of being recycled as an air field. For decades, the runways of Grand Central Air Terminal in Glendale stood within prop-wash distance of the riverbed. During Prohibition, pilots drank bootleg hooch in the air terminal's Aviation Country Club, and if the Feds came busting in the door, the flyboys could hightail it out a secret tunnel down to the river. Now and again, a flyer in trouble did set down his plane in the riverbed. In 1947, an eager politician got the notion of tearing out the bridges and laying down a three-mile landing strip in the riverbed south of First Street. Nobody was buying.

NOW AND THEN, OIL WELLS PUMPED AWAY IN THE riverbed in Long Beach. In Southern California, where a working oil well still makes black gold on the campus of Beverly Hills High School, this was an honorable enterprise, not an environmental nightmare. In truth, more barrels of oil have been poured illicitly down the storm drains and into the Los Angeles River over the years than ever came pumping out of it.

Not long after the river was paved, a small colony of gold panners settled in down along the banks, each giving the other man a wide and wary berth. One had come down from the family ranch in Oregon "to show some of those movie cowboys how a real cowboy should act." To no one's surprise but his, he got nowhere. So he went sluicing for gold and silver and lead and brass and copper in the cement river. Most days he made a buck; on rarer days he made twelve. In the decades to come, the homeless would find their own pocket money in aluminum and plastic, the river's salvage.

In 1896, Griffith J. Griffith gave Los Angeles 4,218 acres of land for Griffith Park, intending it to be a riverfront paradise. Griffith was not

known as a man of tender conscience, yet even he was appalled to see the river brutalized, tons of sand and gravel plundered from its bed at ten cents a wagon load and "even the beautiful trees . . . ruthlessly destroyed."

THAT RIVER—A LAUGH A MINUTE. The comedians couldn't get enough of it. The radio hosts of the 1970s "Ken and Bob Show" could always get through a rough patch by crooning their song, "I Lost My Liver in the L.A. River."

In the next generation, playwright/performer Rick Najera cast himself as a Mexican Moses, found floating down the Los Angeles River and raised by Republicans.

Burbank

Not long after the 1938 flood, newspaper photographer Coy Watson Jr. inveigled his editor into staking him to twenty-five dollars to rent a boat and shoot pictures of flood damage all the way to Long Beach from the river itself.

In their rented skiff, Watson and a reporter loaded a birdcage and a bicycle tire and other ludicrous props and set off for the harbor. The boat was swamped within a mile, to the amusement of some kids who had trailed it along the bank to see "what damn fools" the grownups were making of themselves. Watson salvaged the ship's flag, a darkroom towel with the letters H and E, for *Herald Express*, and stuck it in a corner of the photographers' lounge. (His younger brother, Delmar, working for another newspaper, tried the stunt about fifteen years later and found himself no better a sailor, and the river no more navigable.)

It wasn't a Watson prank but it could have been: the *Herald Examiner*'s startling 1950 photograph of an ocean liner steaming up the river—a sleight-of-hand composite for April Fool's Day.

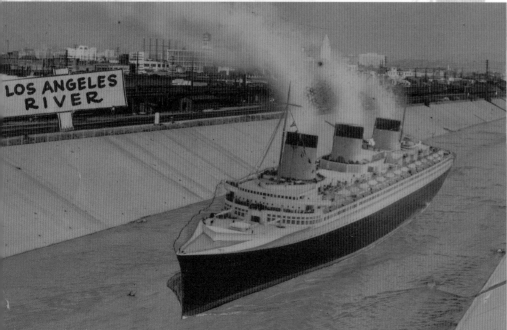

April Fool's Day composite photo, 1950

The Irrelevant River

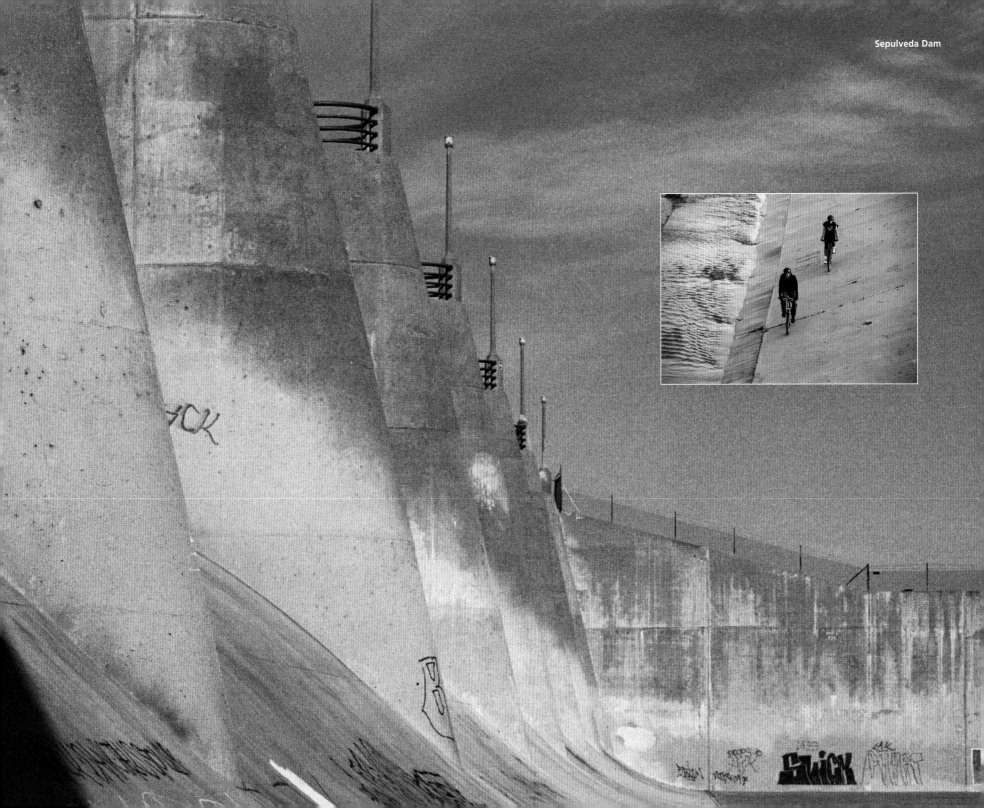

IT WASN'T UNTIL THE RIVER forfeited its riverine nature that people began to think seriously of how they could use it for recreation. The city council in the downriver town of Bell bestirred itself in 1959 to figure out how to dedicate two miles of the river to boating and fishing with inflatable dams. It invited the local congressman, who declared himself mightily impressed with the idea, which is about all that came of it.

A Cal Poly Pomona urban planning and architecture student contemplating the turn of the millennium crafted a plan for an urban park unlike any other, in the river downtown, a different kind of sportsman's paradise from the duck-hunting richness of the old river. This would be a concrete park, with towers and ramps for skateboarding and bungee jumping and rappelling, and an *aprés*-speed cafe on the banks above.

Seven years before Los Angeles hosted the Olympic games in 1984, the city began working out how to use part of the river that flows through the twenty-one-hundred-acre Sepulveda Basin for Olympic rowing events. "We'd have to put some water in there," the Army Corps of Engineers contributed helpfully. But San Fernando Valley folks who didn't want the lake any bigger or busier declared, "Hell, no, they won't row," and the Olympics went elsewhere.

The horse people have been the most durable and stubborn sportsmen and women on the river. Downriver, amid the yammer and clamor of industry, the grandfathered-in private stables and rent-a-rides and backyard horse stalls of Compton and North Long Beach send out quarter horses and ponies onto the river, where there are bridle trails and sometimes where there are none. Aphorists from Xenophon to Will Rogers have been credited with the line about nothing being as good for the inside of a man than the outside of a horse, and on fine weekends, as equine therapy, good-deed programs help handicapped kids and kids on the cusp of trouble to saddle up and plod the river's banks.

Miles upriver, near where the city of Los Angeles stables its police

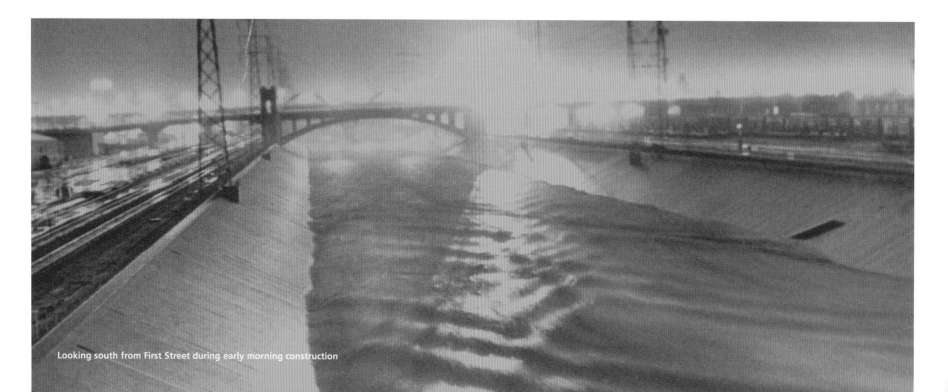

Looking south from First Street during early morning construction

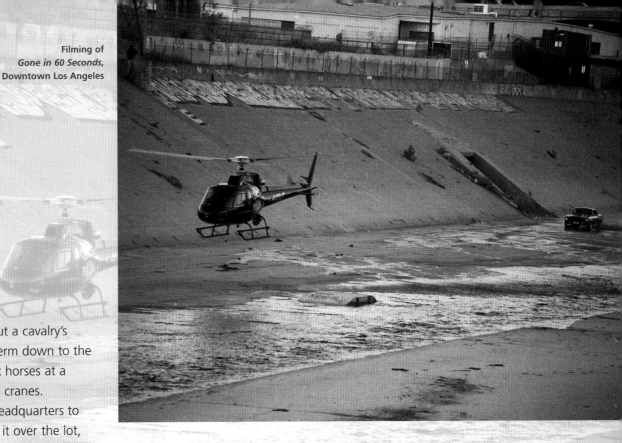

horses, the riverside equestrian center in Burbank sends out a cavalry's worth of riders every weekend, negotiating the earthen berm down to the river, or the bridge at Victory Boulevard—no more than six horses at a time, please—to the "rancho" side, among the ducks and cranes.

The trail takes a rider behind Disney's corporate headquarters to the Warner Bros. studio, where Bette Davis once queened it over the lot, but she was, on these bridle trails, for years, just another neighbor, another rider. Equestrians have ridden here since before World War II, so when "no trespassing" signs went up because someone thought a fence was too low, the riders serenely ignored them, and the crisis passed.

Sometimes the horse people get together and paint out the gang graffiti. If anyone bothered to consult them, they'd say they would rather the river-scythers left the trees and reeds alone, one horsewoman says wistfully, "and just haul away all of that trash, hoodlums included."

THE PEOPLE WHO MAY LIKE THE RIVER best as it is, besides the men who built it, could be the moviemakers. The river gets no credit, no billing, but it probably has more screen time than half the members of the Screen Actors Guild. It works cheap. And it has starred as itself most famously in *Grease*, as John Travolta races in the riverbed and Olivia Newton-John

watches, and in *Terminator 2*, as Arnold Schwarzenegger, astride a motorcycle almost as powerful as he is, careens impassively down the river with a big-rig driven by a liquid-metal being from the future tailgating him.

To Live and Die in L.A. and *Blue Thunder* also have river scenes. But the campiest of all was that anthill Armageddon, *Them*, the nuclear-age saga of giant ants taking up residence in the storm drains of the Los Angeles River. At one point James Arness, the furrowed-brow investigator, visits a hospital drunk tank, talking to a geezer who is obviously loony. Not only does the old coot keep babbling about giant ants down in the river, but that river, the Los Angeles River, he says—"I seen it once when there was water in it."

As it began with nomads,

Sepulveda Dam Wildlife Area

it ends with nomads.

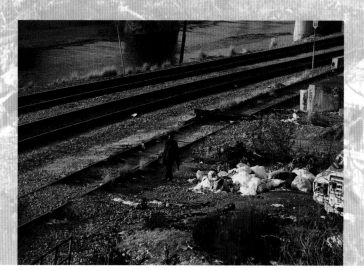

Tribal people lived for thirty centuries in a peripatetic minuet with the river and the water. In the twentieth century, other tribes took up residence along the angled concrete verges. For them the river is not a cipher on the city's maps and minds. It is an authentic place.

Chinese railroad workers pitched their tents on the riverbank in the 1870s. Gypsies camped here in the 1920s, and by the hungry 1930s, it was roaming armies of the out-of-work. The evolving language of the age has called them, by turns, tramps, bums, hoboes, transients, and now "the homeless."

They are homeless in any of the manifold senses of the word—without shelter, without a country. In this illicit bit of open space, in any season but the very wettest, colonies of men, and a very few women, live furtively alongside the lowliest real estate in Los Angeles. A small colony of South American transvestites was sighted, like rare birds, living in 1994 beneath a river bridge.

Here, the river and the dispossessed who frequent it live below the city's line of sight and out of the run of its thoughts.

From Skid Row come the homeless and the mentally unsound. When police flush them periodically from the sidewalks, they come back, here, to the river. In summer, when they can get along without the four warming walls of a cheap hotel room, they come here. From his riverside bench below Atwater, such a man burps a beery burp and gestures to the tree-filled riverbed as if introducing a friend. "This river," he declaims in cheery, slurry Spanish, "this is the lungs of the city."

From the west and north come the immigrants, day laborers who can afford no shelter but this. It is quieter than Skid Row, and safer—"like a suburb," in the words of a man who lived for a time under the Seventh Street Bridge. The river has, in its own desolate inverted way, a suburb's placid quiet, a suburb's space for privacy and even pets. The urban animals, the wild and the domestic and the simply abandoned ones,

find their way here just as the abandoned people have, and here they live amiably together. For such men, the river is their village well, in the opinion of Alice Callaghan, who works among the homeless. It is their town square, bathroom, fishing hole and Laundromat. They lay their clothes to dry on the slanting, sun-heated banks and splash themselves clean in river water. From the train tracks above the riverbed, passengers can look down and see their ablutions. One clear winter day, a man left his slippers on the riverbank, as if he had just stepped away for a moment, and would be right back to snuggle his feet into them.

In the San Fernando Valley neighborhood of Canoga Park, there was for a time a thriving riverside encampment that its residents dryly called "Hotel La Palma," after the tree on the bank. The forty or fifty men who called it home spent their days waiting outside hardware stores for casual work and their nights on the riverbank.

From the east side of the river, the homeboys come to this barren clubhouse to kick back and drink and mess around and start bonfires. They are the just-chillin' dudes, the dreamers and dopers, smoking or shooting or huffing spray-paint fumes from paper sacks, and the painters in search of cement canvases.

The graffitists mark the concrete plains with their whimsies, or the illegible name, rank and serial number calligraphy of gangs. Sometimes they scrawl in Nazca-scale letters the code and scripture of their riverside neighborhoods: Dogtown, for the streets near the old city animal shelter; Frogtown, for the red-legged frogs that were once plentiful at the river's

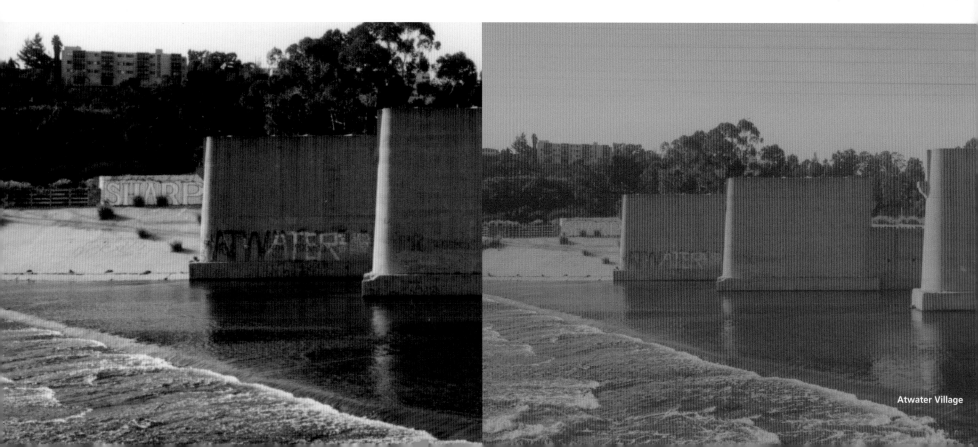

Atwater Village

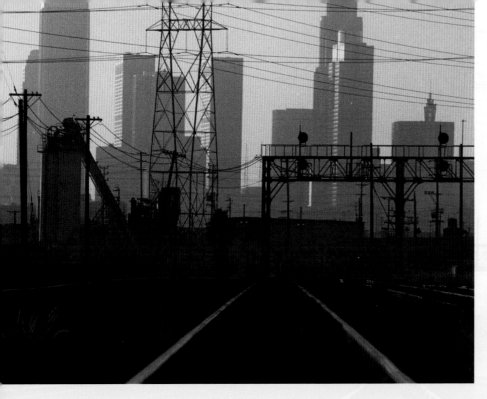

modern pictographs emerging out of the brushes and spray cans of kids, stoned or sober, who have escaped into their own imaginations, along the river where the sacred datura still grows.

ANY POPULATION HAS ITS PREY AND ITS PREDATORS. The river, as it moves south, is the occasional habitat to the bangers of the city's biggest and most ruthless street gang. The river is their shooting range, a place to better their marksmanship by spraying the floating trash with hollow-point bullets. In Cudahy, concealed in the river's cement embrace, they initiated new members in eighteen stopwatched seconds of relentless beatings.

Just being in the riverbed is a crime, but chain-link and locks and the signs about five hundred-dollar fines are insubstantial deterrents. Anyway, the river is a DMZ, a truce space. Once in a while, as happened in 1995, when too many shopping carts turn up stolen and burglaries are too frequent to ignore, the police and the bulldozers sweep out the people and scrape the place clean. Still, as long as no one up in the lofts or the ware-houses complains, as long as the sewage doesn't smell too rank—well, there are other matters to fill a police officer's shift.

In places, the river is wider than a football field is long, big and empty enough to keep almost any secret. The man who planted marijuana in the river must have been counting on that. He did not count on the regular patrols by flood control workers charged with chopping down anything green that might slow down the pummeling winter waters. Right along with the reeds and the weeds, his marijuana got axed.

The greatest river crime was a double offense—the murder of a man, and an assault on the law. Sleepy Lagoon was the newspapers' name for a deserted willow-shaded quarry along the river in the town of Bell. In the wet overreaches of the river before 1920, this was the Laguna Duck Club, where rich Angelenos hunted waterfowl. By World War II, it was a

edge; and Toonerville, from the Toonerville Trolley of the 1930s cartoon, derived from the trainyards on the river's east bank.

Now and then, by happenstance or genetic memory, the loops and whorls and lightning bolts they paint have in them the echoes of the basket patterns of the Gabrieleño, and the pictographs of the Chumash, the Gabrieleños' neighbors. Red, black and white were the favored colors in the ceremonial artwork of these ancient Shoshoneans, and the shapes they created—perhaps during their jimson-weed journeys into imagination and spirit—were variants of the circle, with spokes and rays, and of angles, diamonds and parallel lines. Their art, cut and colored into rock, was the shamans' account of sacred excursions into their own minds, of visions as intimate as the soul and as cosmic as the spiraling celestial galaxies, and the circles-within-circles of the orbiting planets. And on the river's concrete banks today, red and black and white and bold, are yin and Yangna, present-day images from the warrior's hallucinatory quest,

swimming-hole hangout for Hispanics who refused to submit to the demeaning ritual of Mexican-only days at segregated public swimming pools.

In August 1942, a man named Jose Díaz was found beaten to death there after a party. Six hundred Hispanics were arrested, twenty-two indicted and twelve convicted of murder. Just look at them, said the prosecutors, pointing to their zoot suits and *pachuco* haircuts—they must be guilty. Two years after they went to San Quentin, the twelve had their convictions overturned because of judicial misconduct. The murder has never been solved.

The corpses of a couple of Japanese gangsters, *Yakuza*, once turned up in the river, a moment that a filmmaker turned into a movie,

but the river is an unreliable partner in crime. Other rivers obligingly wash away evidence, but anything dropped into this river is liable to stay right where it lands until the winter waters rise.

This is a city that christens its killers by geography—the Hillside Strangler, the Skid Row Slasher. The Los Angeles River Rapist was a jailhouse informant who knew the ways of lawmen. He singled out a Hispanic woman who looked alone and vulnerable and he flashed a badge. "Immigration," he said, and demanded a green card. When she could not show one, he handcuffed her and took her deep into the tunnels to the river, where he knew no one would interrupt, and there he raped and sodomized her. Eight times he did this, before he was caught and sent to prison for seventy years.

Lincoln Heights

The Phantom River

Lincoln Heights

In the inventively noir movie *Chinatown*, about the water wars of Los Angeles, a fictional dick named Jake Gittes, a man who knows the ways of the city and its river, checks out a body in the morgue.

"He got drunk and drowned in the L.A. River," the attendant explains.

"The L.A. River?" says Gittes, who is played by Jack Nicholson and his eyebrows.

"Yeah," says the attendant, "under Hollenbeck Bridge."

"It's as dry as a bone," Gittes points out.

Q.E.D.: that was no mishap. That was murder.

FROM THE CITY'S EAST SIDE, the river came to look like a border, if not a barrier. When the moneyed people moved west, the dowager streets of faded gingerbread houses became cheap, and generations of immigrants, Japanese and Jews among them, got a toehold on the ladder of property.

The Flats, the low land between the river and the foot of Boyle Heights, was a first stop for all manner of immigrants, "much like New York City's lower east side," remembered James Rojas, whose forebears lived there for generations, on streets where neighbors were as tight as families.

Rojas' grandfather was one of those seventeen thousand men who paved the riverbed. But chaining the river beast didn't raise the value of the east side to the civic planners; it simply invited in more factories and freeways and public housing, and finally, only one language was left from the immigrant Babel, and that was Spanish—the same tongue that had first been heard on the banks of the river more than a dozen decades before.

In his collection entitled *The Concrete River*, barrio poet Luis Rodriguez writes of Aliso Village, the housing project that lies "here, across the L.A. River, concrete border of scrawled walls, railroad tracks, and sweatshops, here, where we remade revolution in our images."

The Phantom River

Lincoln Heights

DOWNSTREAM, THE CITIES CHANGED as the river did.

On the wide plain between the San Fernando Valley and Long Beach are towns named for the waters that were once so plentiful—Artesia, for its wells, and Clearwater, now merged into Paramount, for its lake.

Here, where some of the smallest and most crowded of California's cities now shoulder together, farms and ranches prospered far into the twentieth century. Even in winter, the unchanneled river moved slow and wide, and fertilized the land, and a flood now and then was a nuisance but not a tragedy.

The newly built river closed off these wandering waters, and after the suburban boom of the 1950s, the ranches shrank to farms, the farms to gardens, the gardens to bungalows and the bungalows were razed for apartment buildings. Cudahy, the town where people did their errands on horseback and let their goats crop the grass into the 1950s, now has four thousand apartments within its one square mile.

In the city of Paramount—the civic offspring of the union of Clearwater and Hynes—dairy farmers came to post the market price of hay every day on an ash tree within reach of the river's winter flow. Paramount has rustically fenced in the venerable Hay Tree, and set plywood cutouts of Holstein cows around it in remembrance of what it was. Also in remembrance of what it was—a flood zone before the river was confined—the city keeps a twelve-foot dinghy at the ready if the waters rise too high, as they sometimes still do.

Vernon, whose modern motto is "Exclusively Industrial," watched its steel and aluminum factories close. But the fertilizer plant is still there, and the slaughterhouse and meat plant where Dodger dogs are made.

The city of Commerce made the tires that coursed the Southern California freeways. Maywood, the most crowded city in California, was until World War II a getaway town of riverside cottages.

Bell Gardens stands at the point where the Rio Hondo pours its

channeled waters into the Los Angeles River. There, in the heart of a mobile home park, is the two-centuries-old Lugo adobe, the onetime home of Henry Gage.

On a winter morning in 1889, Gage climbed to the top of his windmill and watched as the river rose three feet in thirty minutes. Toward Watts, he saw that the river was five miles wide. When the river flooded the next year, the future governor rowed to a neighbor family's rescue as they clambered out a hole in the roof of their underwater house.

In his crotchety age—he was sent packing after one term in Sacramento—Gage said he had scolded and ranted, Don't build anywhere in the river bed, keep the river from being choked up with willows. But did anybody listen to him? No. And now look.

These towns, neighborly, chipper, hopeful, ambitious, have good reason to bless the concrete walls of the artificial river they cannot see.

Equestrian Center, Los Angeles

The Army Corps was Moses here, parting the waters and making it possible to build suburbs on a floodplain. It isn't Bel-Air, it isn't Rancho Palos Verdes, but it is theirs. And yet here, where they most fear letting the river out of its cage, is where the river's park potential is needed most.

In Pat West, the city of Paramount has as upbeat a city manager as it could want.

He knows water politics as well as Paramount politics, for the two are entwined. Because there is the flood control channel, people could build right up to the river, and because they built right up to the river, they have to have the flood control channel.

He speaks unselfconsciously of "the year the river was built." In the late 1990s, Paramount fought very hard for four extra feet of concrete walls on top of the original ones. Without the walls, their flood insurance went out of sight.

Still, of course, says West, Paramount is "self-conscious about the river," about how it looks and how its only use is in what it is not. "The neatest thing we've done for the river— it's so cool—the three entrances into our town off the river, we've commissioned an artist. We painted aquatic murals on the riverbed,

Mission San Gabriel

on the side of the wall," whales swimming upstream, dolphins, and sharks, "happy sharks. We're doing everything we can to make the river look like a big asset. We try to make lemonade out of a lemon."

110

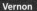

It fell to the artist's imagination

Atwater Village

Boyle Heights

to see the river for what it was,

and what it still had to offer, a place running bank to bank with metaphor and irony and possibility.

Maybe it started with the cats. Not long before the Beatles came to America, somebody—one legend holds that it was a Burbank housewife—began painting whimsical cat faces around the tall riverbed storm drains of Atwater.

You can see them from the Golden State Freeway, gaping and yowling at the traffic. Leo Limon saw them as a little boy heading to the zoo, and as a grownup he created fifteen of the thirty-two river cats. The January-to-March rains fade the color, the gangsters mark up the cats with their own scrawlings, and back Limon comes to spruce them up, sometimes with kids from a youth-at-risk project as his assistant brushworkers.

The county flood control people maintain a mural registry so their workers, as they make the rounds to clear the trees and plants and boulders and stones that could slow the water's winter race to the ocean, know what paintwork they are supposed to blast away and cover up, and what to preserve. The cats are first in the river's permanent collection.

The clear light and gentle weather have made Los Angeles the world's mural capital, and in paint, if not in concrete, the river registers on the retinas. On the flood-control channel walls of the Tujunga Wash,

across Van Nuys and North Hollywood, is the half-mile-long "Great Wall of Los Angeles." It took seven years to paint its forty-one scenes, the handiwork of poor kids and kids with crime problems, "juvies." The artist who supervised the monumental mural, Judith Baca, painted the river again at a student center on the University of Southern California campus, envisioning it as a river that becomes a freeway that returns to a river once more.

By the 1990s other artists had begun to put the river center stage:

. . . Seven poems commissioned about the river, among them Russell Leong's "Knowing the Water," which begins, "It's time you knew / The center of the world was always here: / summer silt island on a river / Just below Ripple and Fletcher."

. . . A show by four artists, two Hispanic and two Japanese-American, called "Riverfront Properties."

. . . "Dry River," Dave Alvin's bluesy, lovelorn parable of a concrete river channel swept by rain.

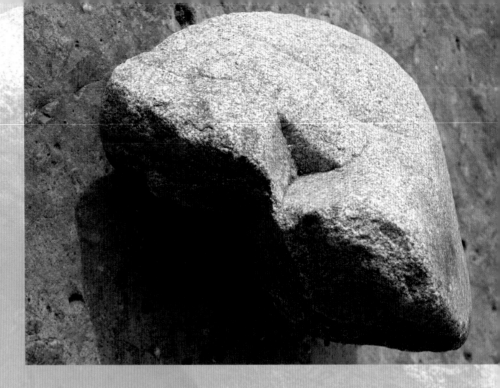

. . . "L.A. River" by E and Jennifer Condos, a lovelorn lament ending with, "I'd dive right in an' drown / but there's no water / My head may hit the ground, but I'm still here / Poor river, L.A. River / I'm feeling just like you."

. . . Hiro Yamagata's striking illumination of two miles of riverbed a downtown bridge.

. . . Urban choreographer Heidi Duckler's onsite performance piece, "Mother Ditch," a river odyssey in rubber boots, a violinist in a canoe, a girl in a shopping cart amid the trash, all with the benediction of the Gabrieleño Tongva Tribal Council.

. . . "East of the River: Post Grafitt" (sic), sculptures assembled from the syringes and spray cans and other detritus collected from the river's east bank.

. . . In the passageway between the Art Deco Union Station and the twenty-six-story transit headquarters, the floor is inlaid with bronze

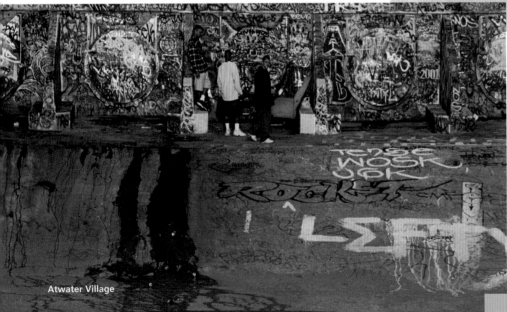

Atwater Village

The River Resurrected

replicas of the flora and fauna that once swam and swirled in the river.

But maybe the most important river art was a performance that tanked.

In September 1985, Lewis MacAdams put on a show.

A friend and chronicler of the beat poets, he too is a poet, and author of a jazz book called *Birth of the Cool*.

Onstage at the now-vanished Wallenboyd Theatre in the flower- and-produce district of downtown Los Angeles, MacAdams put on what he called "the first act of a forty-year artwork to bring the Los Angeles River back to life through a combination of art, politics and magic."

The first part, a collage of video, film and slides, "resembled a high school social studies project," the *Los Angeles Times* reviewer wrote. In the second, MacAdams, in a white suit and watery-colored face paint, channeled the ghost of William Mulholland and did river-animal impressions. "With friends like MacAdams," the reviewer summed up dismissively, "the river needs no enemies." In all, it was so dismal that the theatre wouldn't pay, and his girl-friend dumped him.

Nothing marks the start of the Los Angeles River, not even on the Canoga Park High School playing field where the river masters fixed the river's beginning. But it is possible to mark the beginning of the revival movement for a trashed river, in MacAdams' piece of trashed performance art.

NOT SINCE THE FIGHT THAT Los Angeles put up against coastal oil drilling, and the founding of the Heal the Bay movement to sanitize the sump that Santa Monica Bay had

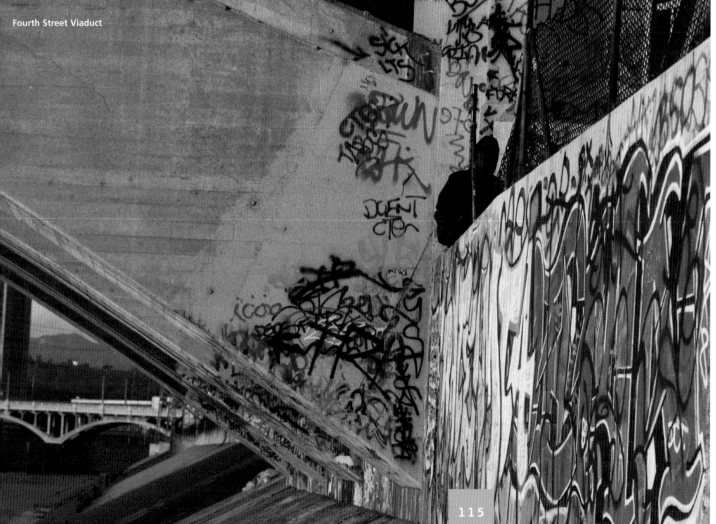

Fourth Street Viaduct

become, did a local environmental cause catch on like the one MacAdams took up.

It was all the more remarkable because the river lies far off the radar of the *cause célèbre* neighborhoods of west Los Angeles, whose residents often give the impression that they are more familiar and comfortable with Manhattan than with the east side of their own city.

The group MacAdams founded, Friends of the Los Angeles River, FOLAR, was soon joined by powerful allies: watershed and mountain and land trust and tree and wildlife and environmental groups, task forces and not a few politicians. An aide to one of the latter tried to explain his boss's interest: "We're trying to make the river more than a concrete block."

All of them had looked around and seen a city suffocated by concrete and throttled by crowding—and here was this wasted open space of an entombed river. Enough, they decided. Time to bring out the paddles and revive the river.

The river's engineering was a marvel of its day, but its day was sixty years past. We'd conquered smallpox and reached the moon since then. Surely, they argued, waterworks technology had come up a few notches since the Depression.

Titled people from the Los Angeles City Council up to the federal Environmental Protection Agency agreed: The river could not safely be set completely free, but recreation and cement could undoubtedly cohabit. Walking trails and bikeways and bridle paths were built, extended, improved, and plans laid for more.

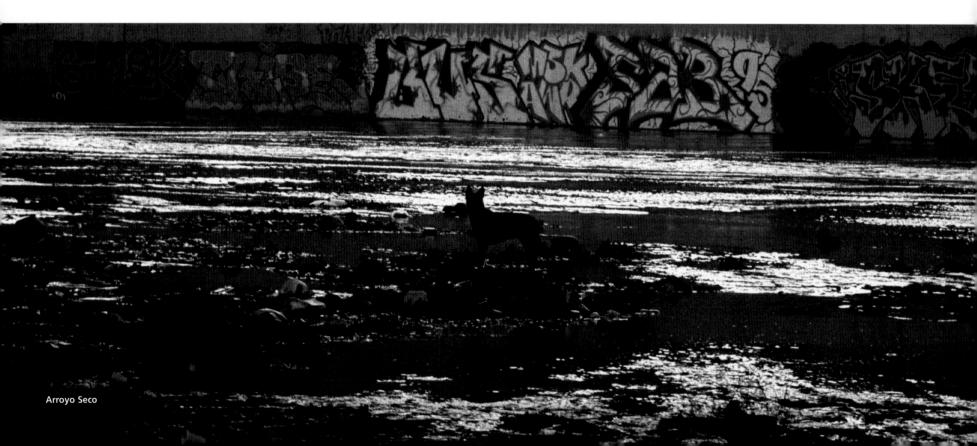

Arroyo Seco

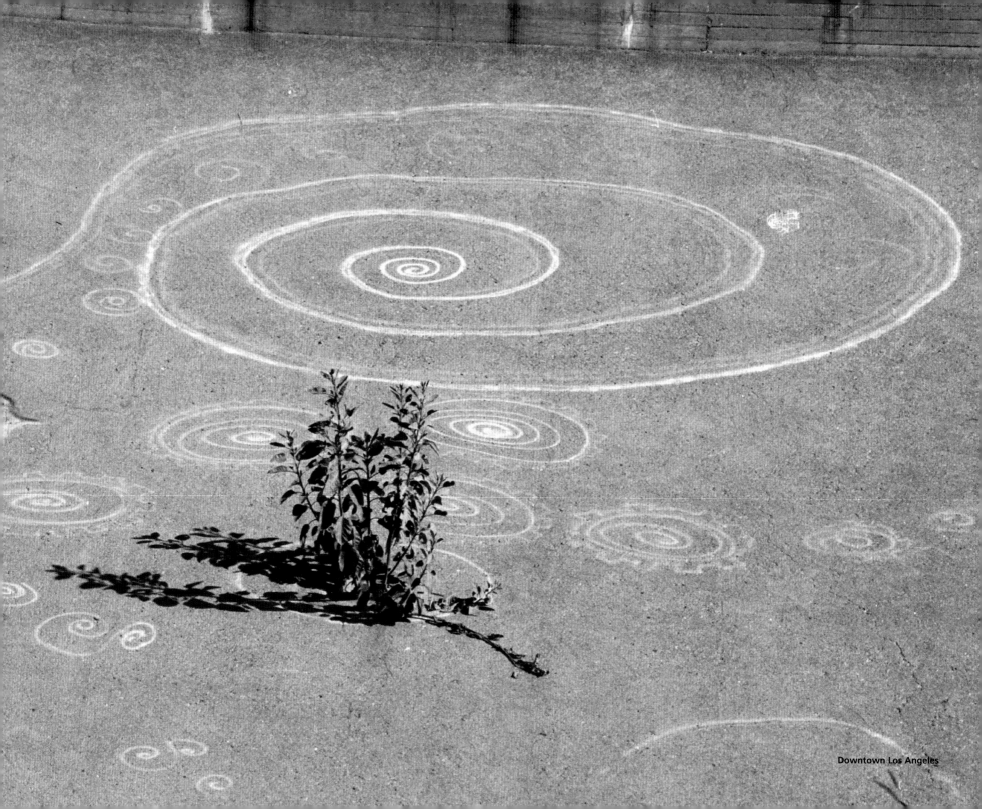

Downtown Los Angeles

Environmentalists, often savaged as being green and very white, were joined by Hispanic families and Chinatown residents, desperate for more park land in a place that has the worst park-to-people ratio of any big city in the nation.

When a children's soccer club in the Cypress Park neighborhood near downtown Los Angeles found itself canceling games and practices because there was no place to play them, moms and dads pushed their baby strollers to a demonstration and signed on with environmentalists in a lawsuit. One young father said, "We don't want more warehouses. We need a park."

In the downriver town of Maywood, the most crowded city in California, parks workers had to step in to settle arguments over who gets

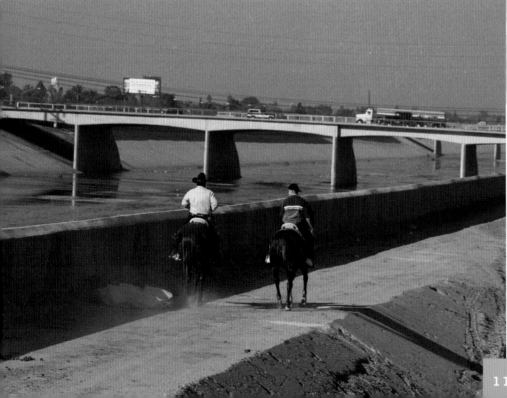

Paramount

to use the overbooked soccer fields and baseball diamonds. In other towns downriver, with big populations like Maywood, the leaders began looking to the river for some green space.

In 1990, the river revival movement had picked up enough momentum that Los Angeles Mayor Tom Bradley, a most cautious politician, created a river task force to see what could be done to make it "an oasis of beauty and opportunity." A half-million dollars came out of Sacramento for a new river master plan with an eye to sports fields and picnic grounds and pocket parks and even wetlands. The echo of Frederick Law Olmsted Jr.'s wishes and warnings could be heard again.

To loosen the strings of the river's concrete corset, even a little, might mean buying up land and perhaps even houses to widen the bed.

The River Resurrected

Expensive, yes, but park space anywhere is expensive, the river folk contended, and the Corps had made out big checks before, to buy farmland and houses when it built the concrete river. Why shouldn't a new river avatar do the same?

American Rivers Inc. adopted the Los Angeles as one of the nation's most endangered rivers—significantly, recognizing it as a river. Each year since it began in 1989, *La Gran Limpieza*, the big cleanup, more people turned out, from Sunland to Long Beach, to de-crap the river. Occidental College, the highly regarded private liberal arts college a couple of miles from the river in Eagle Rock, hosted a year-long symposium on the subject. A Web site gives virtual tours of the river.

And the paradox was beginning to register, too: billions of gallons

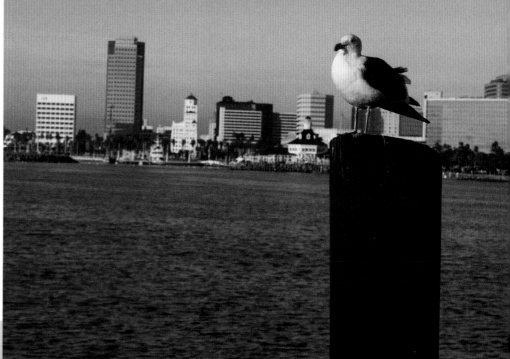

Long Beach Harbor

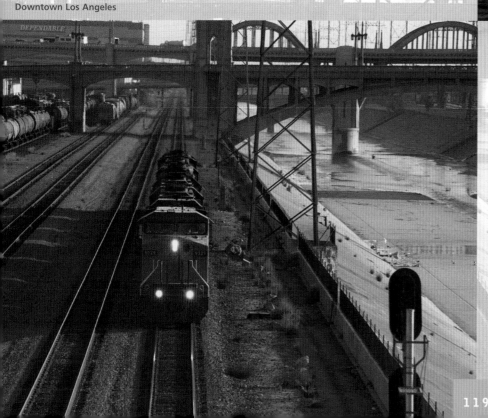

Downtown Los Angeles

of river water hustled out to sea across the mid-section of a water-starved land. After the droughts of the 1980s, Los Angeles laid down strict water rules, and it kept them on the books. Hosing down driveways and sidewalks is still against the law. And yet a year's worth of water for a million people was swept to sea in the flood month of February 1991. How could Los Angeles spend millions to get rid of its own rainwater at the same time it was bringing other people's rainwater here from miles away?

Herbert Hoover, the engineer who became president, once observed that the engineer's lot in life is to torment himself with worry "at the thought of the bugs" in what he has designed, and to be damned "if his works do not work." The engineer-president whose name adorns the massive dam that pens up the waters of the Colorado River also declared

Atwater Village

with presidential certainty that "every drop of water that runs to the sea without rendering a commercial return is a public waste."

The apparatus of flood control is so efficient at what it does that only about fifteen percent of runoff destined for the river ends up being recycled into the earth. The river restorers argued that if more of the river water had room to seep back into the watershed—ideally along the river— it could be put to good use instead of just hosed away into the harbor.

At the turn of the twenty-first century, California anted up eighty-three million dollars for a Los Angeles River state park, the first state park in seventeen years.

Before the river revival movement, it might have passed unnoticed by anyone but historians when a five-foot fragment of the original *zanja*

madre was unearthed below the cliffs of Chinatown. In the year 2000, it was news. Who'd have thought? A two-hundred-year-old brick-covered ditch, on TV.

The most outward and visible sign of the river awakening is the Los Angeles River Center, a lush bit of gardens and buildings that almost got taken over by a box store. It is the epicenter for studying and celebrating the river, but as a gauge of its task, when the center opened in 1998, the map illustrating it in the newspaper helpfully showed all the nearby freeways, but left out the river.

BUT IT'S NOT EASY BEING GREEN. To some of the engineers and flood control experts, all this talk of freeing and greening the river is as dangerous

and foolhardy as leaving live electrical wires lying around, or trying to dress up a sewer.

"Safety first, and last," could be their motto, or maybe "Our work is never done." When a congressman put a million dollars into the Army Corps of Engineers' pockets in 1991 to study how to make the river cleaner and greener and more riverlike, the Corps only spent a quarter of it, and made it clear it considered the whole exercise an expensive wild goose chase. River restoration is a pretty notion, the Corps said, but these people aren't engineers. In the meantime, the Corps was spending more than seven million dollars to study more flood control, which meant more concrete, higher walls, and stronger levees.

The opposing forces have matched their weapons over the river like the Yankee troops and the *Californios* who once battled on its banks. The flood control authorities start to bulldoze the brush and trees that grow in the natural bottoms of the river and its tributaries, lest they slow down the winter floodwater. The environmentalists parry with the fact that the natural bottoms make them streams by law, not flood control channels, and you can't just go in and scalp everything.

With the birth-announcements of El Niño storms in the 1990s, flood officials won permission to top the levees with another four feet of concrete along the lower river and Compton Creek and the Rio Hondo. Without the walls, the flood experts said, the land along the river ran the risk of being drowned in another hundred-year flood, like the one in 1938. And, furthermore, without the security of the walls, they warned, there was the near-certainty of exorbitant flood insurance that the people living in the small, working-class cities downriver would have to pay.

A FUNNY THING WAS HAPPENING, THOUGH. People started regarding the Los Angeles as a real river.

For about ten miles of the river above downtown where the soil was too wet to pave, trees and reeds were allowed to grow. Waterfowl settled in. Seagoing birds were seen at the river now and again, and it was

Long Beach Harbor

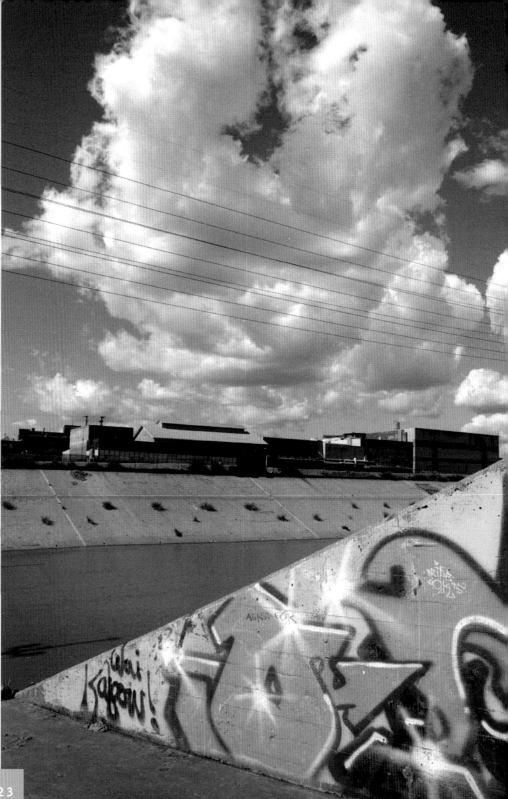

flowing every day with fifty-five million gallons of water purified by the Los Angeles and Glendale treatment plants upriver. Trees were planted and benches installed beneath them. River tours and river walks guided people along a river they had never seen.

On Rosh Hashanah in 1993, dozens of members of the Temple Beth Solomon of the Deaf, in the San Fernando Valley town of Arleta, linked arms and walked to the riverbank, leaning over the railings to drop bread crumbs and watch them carried away in the crawling September waters, symbolic of the casting-off of sins.

And there was Ernie. Ernie LaMere, seventy-seven years old when he took a weedy, crummy, junked-up trail along the river in Sherman Oaks and adopted it, hauled in leftover geraniums and marigolds from his own garden and planted and pruned until the place was a bower a quarter-mile long. Neighbors dragged over pepper trees and lilies and he planted those too. Along the bank he crafted surprises for strollers—benches and comic tombstones and an inflatable Godzilla, a kind of horizontal garden version of the Watts Towers. Here he played the maitre'd as he had done for a living his whole life: A little fruit? Something to read while you sit?

When Ernie died in 1995, they did as he had asked, and scattered his ashes into the river that runs below the walk that now bears his name.

THE GENIE OF THE RIVER, once freed, will not go back inside his concrete bottle without a struggle. The river rebirth movement is finding patterns and opportunities, conflict versus compromise, upriver versus downriver, green versus cement.

Like someone shattered by war, the river can never be whole again, can never be the real, sometimes too-real, river it once was, and for so many reasons of life and livelihood, it should not.

But it can be something better. It ought to be. Parole the Los Angeles River; it has served its time.

Photographer's Afterword

Glendale

When people ask me why I chose the Los Angeles River as the subject of six years of my work, I laugh because it really chose me. This may seem a strange tale but here goes. I followed two paths, two seemingly disparate paths, but they merged and led me to one place.

When I began photographing the river, I was overwhelmed by the spirituality that emanated from its waters. As I watched the river flow, past centuries merged with my present. I became obsessed with the original people who lived along her banks for thousands of years. My quest for as many details of their history became what these Native Americans had called a "vision quest."

As I opened my eyes to see what I could see, the second path laid itself open to me. I stepped into this invisible river—a world of tunnels, caves and strange graffiti art—and I suddenly knew I was standing in what could be the largest surrealistic painting in the world. What a challenge I felt: here I was staring at magnificent explosions of color spanning hundreds of feet—graffiti that was being covered up as fast as the taggers and gifted artists could put it up—and yet I couldn't make out what these kids were trying to say. To me. To you. To all of us.

It was easier to research the Native American people who lived here before we came. I wanted to know what they believed, what the river meant to them. Like an anthropologist studying the ancient Egyptians of the Nile or the Hindus of the Ganges, I let the L.A. River Indians become my guide. The L.A. River basin Indians were descendants of the mighty Shoshone tribe. According to the Shoshone, thirteen tribes emigrated from the northwest territory, one of whom became a super tribe of seafaring, sun-worshiping, rock-painting, hallucinating Indians who carried with them a very powerful creation myth. These original Angelenos believed that gods lived in our river and that "little people"—known as *nunashi*—were the guardians of the waterway who could metamorphose into and out of

rocks. And so the people treasured the rocks, celebrated them, decorated them. These powerful spirits paddled stone canoes and painted the rocks and caves with art we now know as petroglyphs and pictographs. The original people of Los Angeles believed that the paintings that embellish the river—past, present and future—were direct messages from God.

Of all the cultures that have populated the earth, the Native Americans of the Los Angeles River basin—the tribe the Spaniards called Gabrieleños—had attained a perfect harmony with nature unsurpassed in the history of civilization. I view them as the most advanced people of this great continent. They protected the Los Angeles River for as long as they could.

Fast forward to the graffiti painted on the concrete walls of the river. When I first viewed it, I knew virtually nothing of graffiti; they don't teach "Graffiti" in college. Matter of fact, it's considered anti-art and a crime in the California penal code. But looking at the artwork that was there, blatantly waiting for the world to absorb it, I felt what every artist feels in the presence of something life-changing: I was moved. I experienced what I knew should be the focus of this work. The words of Leonardo da Vinci,

likening his own fears to a cavern, echoed in my head: "Driven by burning desire, anxious to see the abundance of strange and varied craft Nature creates . . . I arrived at the entrance and paused there a moment astonished . . . two emotions arose in me, fear and desire: fear of the dark, menacing cave, and desire to discover if it concealed some marvel or other." I realized that I must show the Los Angeles River for what it is: a spiritual and inspirational haven, whose impact has been profound for its lifetime.

After studying the Native Americans who lived in the basin, and after looking at the graffiti art that comes and goes today along the banks of the river, I made the logical connection. I realized that just as the descendants of the Shoshone were trying to communicate their emotion centuries ago, the people who live by the river today are doing the same. If they are taggers, so too were the Native Americans of long ago. Through some divine accord, probably linked to altered states of consciousness, the Indian rock artists influenced by their jimson weed have been supplanted by a new breed of painters: the river's twenty-first-century children, influenced by crack cocaine and full of rage, who paint this river with a vengeance. And yet, the local government spends one hundred fifty million dollars a year trying to eradicate something as primal as fire. I became determined that the link between the river and its art should be showcased, before it is lost—the way museums have attempted to preserve the petroglyphs and pictographs. Unlike the ancient carvings, the messages spray painted on the walls of the L.A. River—and then silenced with anonymous gray paint to destroy their colors and their messages—cannot be recovered.

As I photograph along the river, showing the river as it flows and the art as it glows along its banks, I also see red hawks returning. The Indians would say the hawks are good omens. There is no reason why, as Patt Morrison said in these pages, that we as a society cannot bring back a natural harmony with the waterway that has been our collective lifeblood for centuries, our roots and heritage. We should be proud of the Los Angeles River and the art that she inspires. We must never forget the mantra of so many Native Americans who thrived by her water, "Beauty within, beauty below, beauty above, beauty all around me." It is the mantra of *Río L.A.*

—MARK LAMONICA

Index

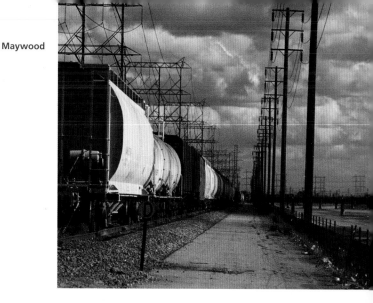

Atwater Village

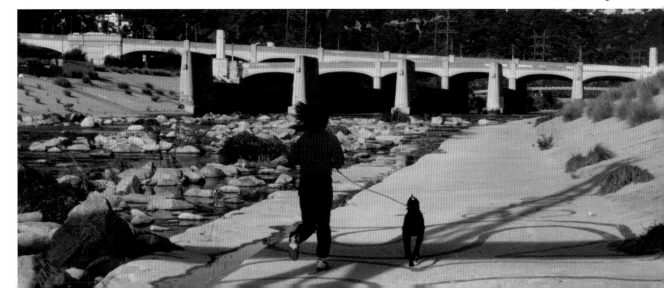

Acknowledgments

No hosannas are sufficient for the indefatigable spirit and patience of Charlotte Gusay, who coaxed and prodded and inspired and persuaded until she had midwifed this book into being. Her sense of synergy brought together the painterly eye of Mark Lamonica, Amy Inouye's talent for capturing verve and style on paper, and Paddy Calistro and Scott McAuley's great love for books in general and appreciation for this idea in particular.

Thanks go to Cecilia Rasmussen . . . to the generosity and renaissance knowledge of Kevin Starr . . . the research of Ralph Shaffer, John Crandell and Stephen D. Mikesell, and the myriad scholars and lovers of Los Angeles' history . . . the one hundred twenty years of work by *Los Angeles Times* colleagues and librarians past and present . . . Delmar Watson and his family's extraordinary news photography archives . . . "Mr. L.A." Tom LaBonge . . . Friends of the Los Angeles River, its founder, the poet and writer Lewis MacAdams, and its waterborne cicerone, Denis Schure . . . Kathleen Bullard at the Los Angeles River Center . . . Vik Bapna and Melinda Barrett of the Los Angeles County Department of Public Works . . . Wayne A. Stroupe and Fred-Otto Egeler of the Army Corps of Engineers . . . Ann Herold, Elke Corley, Guy Logsdon, Katie Klapper . . . Carolyn Cole of the Los Angeles Central Library . . . Jay Jones, acting archivist of the City of Los Angeles . . . Dace Taube, curator of USC's Regional History Collection . . . equestrians Nobel Merriett and Corrine Paige . . . Claudine Burnett of the Long Beach Public Library . . . Lindsey Groves and Gina Ward of the Los Angeles County Museum of Natural History . . . the Southwest Museum . . . Alice Callaghan and Jeff Dietrich, who work among the homeless . . . North East Trees . . . the Southwest Museum . . . Clair Martin of the Huntington Library and Botanical Gardens . . . and the immaculate mind of Gary Snyder.

Thanks also to E for agreeing to the use of lyrics from his "L.A. River" song, to Neil Schroeter at Dave Kaplan Management for his assistance, to Paul Brooks at Rondor Music/Universal Music for his help . . . and to Charmaine Milder and her friend, J.R., for alerting us to the song. Thanks, too, to Evelyn Sasko of The Richmond Organization for permission to use the words of Woody Guthrie's matchless music. And thanks for Curbstone Press for permission to quote from Luis Rodriguez's collection, *Concrete River*, and to Russell Leong for permission to quote from his poem.

When I finished writing this book, I was fortunate to be able to check my dates and figures against the encyclopedic scholarship of Blake Gumprecht's masterly book, *The Los Angeles River: Its Life, Death and Possible Rebirth*, from Johns Hopkins University Press.

—PATT MORRISON

In addition to the above acknowledgments, I would like to thank Patrick E. McCulley for his invaluable service and his uncanny ability to constantly create solutions. My gratitude goes to Sheldon Abend for his continuing guidance. Thanks go also to Alfred Caruso for his support, and to Costco and Colorland in Pasadena for their exemplary service. My gratitude to the angels Sheila Perkins and Ann Calistro. And, finally, thanks forever to Lady Morrison.

—MARK LAMONICA

Photo Credits

All photographs © Mark Lamonica except as listed below.

Satellite image of Los Angeles on book cover and page 14 courtesy of the Jet Propulsion Laboratory, Pasadena.

Pages 52-53, 64 (middle): *Los Angeles Times*.

Pages 55, 67, 70, 77, 98: Los Angeles Public Library.

Pages 58, 59, 60, 61, 62 (left), 63, 64 (left and right), 68-69, 100: Delmar Watson Photography Archives.

Page 79: LACDA model photos courtesy of the U.S. Army Corps of Engineers.